Nature Transcribed

The Landscapes and Still Lifes of

David Johnson

(1827-1908)

This exhibition is made possible through the
generous support of Mr. and Mrs. Richard J. Schwartz,
Cornell University Class of 1960,
the National Endowment for the Arts, a federal agency,
and the New York State Council on the Arts.

Herbert F. Johnson Museum of Art,
Cornell University, Ithaca, New York
November 5-December 23, 1988

The Art Gallery
University of Maryland, College Park
February 1-March 5, 1989

Georgia Museum of Art
University of Georgia, Athens
April 1-May 7, 1989

National Academy of Design
New York, New York
July 10-September 10, 1989

Nature Transcribed
The Landscapes and Still Lifes of
David Johnson
(1827-1908)

An exhibition organized by
Gwendolyn Owens

Herbert F. Johnson Museum of Art

Distributed by University Press of New England,
Hanover and London

Cover:
Brook Study at Warwick, 1873
Oil on canvas, 25⅞ x 39⅞ inches
Munson-Williams-Proctor Institute, Utica
Cat. No. 34

Title Page:
Harlem River Aqueduct, c. 1860
Pencil on paper, 12¼ x 18⅛ inches
Courtesy, Paul Worman Fine Art, New York
Cat. No. 42

Photo credits:
The Anschutz Collection; Fig. 3
Berry-Hill Galleries; cat. 5, 17, 21, 29; Fig. 2
Fine Arts Museums of San Francisco; cat. 24
Geza Fekete; cat. 6
Emil Ghinger; cat. 27
Dennis Griggs; cat. 41, 46, 48, 49
Hirschl & Adler Galleries; cat. 1, 31; Fig. 1
Bernard & S. Dean Levy Inc.; *Self-Portrait* of the artist
and cat. 25
John Lutsch; cat. 35
Otto Nelson; cat. 20
Steve Shipps; cat. 2
Photographs for catalog numbers not listed were
provided by courtesy of the lending museum or
collector.

ISBN 0-87451-487-8
Library of Congress Catalog Card Number 88-82997
Design by Grant Jacks
Printed by Eastern Press, New Haven, Connecticut
Copyright ©1988 by the Herbert F. Johnson Museum of Art,
Cornell University, Ithaca, New York, 14853

CONTENTS

FOREWORD

Until the 1870s in America there was virtually no conflict between what painters like David Johnson were producing and what the public and critics demanded. For perhaps the last time there was a happy union between the aims of artists and the taste of the public. Johnson exhibited frequently at the National Academy of Design and was highly regarded by colleagues and critics both for his landscapes and for his still lifes. By the end of the decade, however, the tenets of the Hudson River School tradition were wearing thin, and many artists and critics were looking for new solutions. David Johnson and several other New York artists adopted versions of French Barbizon painting, replacing the detail and tight brushwork of the Hudson River School with a broader handling and more atmospheric tones. Although critically acclaimed, the later paintings never achieved the popularity of his earlier work, and he died in near obscurity.

Perhaps because of the decline of his reputation in his later years, David Johnson has never attained the prominence of some of his fellow Hudson River School artists. This is the first museum exhibition devoted to his paintings since his death in 1908.

The credit for conceiving and organizing this significant exhibition belongs to Gwendolyn Owens, who began the project nearly four years ago when she was curator of painting and sculpture at the Johnson Museum. Amid many other responsibilities, both at the museum and elsewhere, she found the better paintings and drawings, secured funding, wrote the catalog essay, and supervised every phase of the exhibition's formation. Now director of The Art Gallery, University of Maryland, College Park, Ms. Owens has brought to fruition *Nature Transcribed: the Landscapes and Still Lifes of David Johnson, 1827-1908.* After its initial showing at the Herbert F. Johnson Museum of Art, the exhibition will travel to The Art Gallery of the University of Maryland, Georgia Museum of Art at the University of Georgia, and the National Academy of Design in New York. We hope that through these showings and the research undertaken for the catalog, David Johnson's reputation will be restored and his work will once again command the recognition it so richly deserves.

Thomas W. Leavitt, Director
Herbert F. Johnson Museum of Art, Cornell University

LENDERS TO THE EXHIBITION

The Adirondack Museum, Blue Mountain Lake, New York

Albany Institute of History and Art, Albany, New York

Alexander Gallery, New York

Amon Carter Museum, Fort Worth, Texas

G. Gordon Bellis

Bowdoin College Museum of Art, Brunswick, Maine

The Brooklyn Museum, Brooklyn, New York

Benjamin C. Buerk

The Cleveland Museum of Art, Cleveland, Ohio

Jeffrey and Dana Cooley

Henry Melville Fuller

Herbert F. Johnson Museum of Art, Cornell University,
Ithaca, New York

Hirschl & Adler Galleries, Inc., New York

The Janville Collection

Marilyn Kerner

Kenneth Lux Gallery, New York

Mr. and Mrs. David A. McCabe

Mead Art Museum, Amherst College, Amherst, Massachusetts

Memorial Art Gallery of the University of Rochester,
Rochester, New York

Montgomery Gallery, San Francisco, California

Munson-Williams-Proctor Institute, Utica, New York

NYNEX Corporation

Phoenix Art Museum, Phoenix, Arizona

Reynolda House, Museum of American Art,
Winston-Salem, North Carolina

Elizabeth and Robert Sincerbeaux

Spanierman Gallery, New York

Wadsworth Atheneum, Hartford, Connecticut

D. Wigmore Fine Art, Inc., New York

Paul Worman Fine Art, New York

and anonymous lenders

ACKNOWLEDGMENTS

When I decided to pursue a study of David Johnson, my idea was greeted with enthusiasm by Thomas W. Leavitt, director of the Johnson Museum of Art. I soon discovered that the art of David Johnson —who was, by the way, not related to the benefactor of Cornell's museum — had interested a number of collectors and scholars. The late John I.H. Baur, author of the 1980 article on David Johnson in *The American Art Journal* and a long-time admirer of the artist's work, was extremely helpful to me in the early stages of the project. I feel privileged to have met and worked with John Baur, albeit briefly. Linda Ayres, curator of painting and sculpture at the Amon Carter Museum, also shared her knowledge of Johnson's work and reported back to me on numerous paintings that she had seen by the artist.

Margaret C. Conrads, who with John Baur organized the exhibition of David Johnson's drawings held earlier this year at the Hudson River Museum, author of the forthcoming catalog of American paintings at the Clark Art Institute, also deserves special mention. She willingly shared her Johnson files, which included a collection of nineteenth century newspaper articles that had been compiled by Merl M. Moore, Jr. Because Ms. Conrads and I both found ourselves living in Williamstown, Massachusetts during the 1987-88 academic year, she was in the position of being the first to hear every theory about the artist that crossed the author's mind. I am grateful to her for her patience and her insight.

The exhibition itself would not have happened without the generosity of the lenders who are listed elsewhere in the catalog. Many collectors had their own files of information on David Johnson and with their help I found more pictures and documentation. The Janville family, whose ancestors knew the artist and his wife, graciously answered many questions. My research also benefited from the use of files at Berry-Hill Galleries, Hirschl & Adler Galleries, Bernard and S. Dean Levy Inc., Kenneth Lux Gallery, and Vose Galleries.

Many other individuals helped at various stages of the project. I am grateful to the following people: Carey Bartram, Manufacturers Hanover; Sarah Cash, National Gallery of Art; Bruce Chambers, Berry-Hill Galleries; John W. Coffey, North Carolina Museum of Art; Elizabeth Cunningham, The Anschutz Collection; John Davis, former research assistant at the National Academy of Design; Diane Dillon, Yale University; Timothy Doyle; David Findlay, David Findlay Gallery; Abigail Booth Gerdts, National Academy of Design; William Gerdts, City University of New York Graduate Center; Donald Keyes, Georgia Museum of Art; May Brawley Hill; Diana Linden, The Brooklyn Museum; Sarah Lipsky; Peter Marks and Ian Merwin, Cornell University; Sally Mills and Mark Simpson, Fine Arts Museums of San Francisco; Kevin Moss; Alexandra Murphy; Eric Paddock, Colorado Historical Society; John Peters-Campbell and Cynthia Wayne, University of Maryland; and Eric Widing, Richard York Gallery.

Research assistance on the project was provided by Jennifer Huffman, a former Johnson Museum intern and a graduate student at Williams College, Brooke Marler, also at Williams College, and Debra Arcamonte, at University of Maryland. The record of Johnson's paintings included in the catalog could not have been compiled without the help of each of these three young scholars. The catalog essay benefited enormously from the criticism of Peter Gibian.

At the Johnson Museum, where I began this project as a staff member and completed it as a guest curator, I am indebted to many staff members (both past and present) for their help. Thomas W. Leavitt remained supportive throughout the long process of researching and organizing the exhibition. Cathleen Anderson, Kim Bush, and Nancy Harm all worked to see that the best possible arrangements were made for the transportation of the works of art to Ithaca and for the entire tour of the show. Publicity was handled by Jill Hartz, and the unglamourous task of paying the bills was handled by Robert Paratley and Linda Jones. Donald Feint's quiet patience once again made the hanging of the exhibition a sane process. Dorothy Reddington helped to find support to make the exhibition become a reality and Leslie Schwartz was responsible for coordinating all these tasks (and more) at the museum. Finally, my profound thanks go to Mary Mathews who handled the actual paper work for the show and kept it in an organized fashion which made it possible for me to work on the exhibition from several hundred miles away.

I am grateful to Mr. and Mrs. Richard J. Schwartz, Cornell University Class of 1960 for their generous contribution to the Herbert F. Johnson Museum of Art which helped to make the exhibition possible. The museum also received grants from the National Endowment for the Arts, a federal agency, and the New York State Council on the Arts; I am also appreciative of their support for the project.

The catalog design is the responsibility of Grant Jacks to whom I am grateful, not only for the book that is the result of his effort, but also for the fine job he did in coordinating the production with Eastern Press in New Haven. The text was edited with characteristic patience and care by Shirley Jacks. As usual, mistakes that remain are the responsibility of the author.

Gwendolyn Owens, Director
The Art Gallery
University of Maryland, College Park

INTIMATE DETAIL: THE LIFE AND WORK OF DAVID JOHNSON

Gwendolyn Owens

"The Brook Study...is an out door study, painted entirely upon the spot and is, as far as I was able to make it so, a literal portrait of the place." David Johnson, Letter to G.W. Adams[1]

"'Esopus Creek' and 'Scene at Hurley' are pleasant transcripts of nature." *The Home Journal* (New York) 4 June 1859, p.2.

David Johnson was, above all, a careful observer of nature. His landscapes and his still lifes, his full-scale paintings and his smaller studies, are remarkably exact renderings of botanical detail and geological structure, built from a lifetime of acute attention to natural forms. Johnson's clear eye records with precision the species of each tree in a forest, the blemish on each pear in a still life. He asks the viewer to join him in celebrating the beautiful pattern found in splinters of wood on a yellow birch stump. Over the span of his long career—his works date from the late 1840s to the early twentieth century—Johnson witnessed dramatic shifts in the American taste for landscape paintings, from the naturalistic detailing of a Hudson River, Luminist, or Pre-Raphaelite vision to the general atmospherics of a French Barbizon-inspired style. But while Johnson experimented with, and adapted to, these changing critical fashions, and indeed contributed works which were significant and influential in the development of each of these painterly schools, the dominant, informing spirit behind his entire oeuvre remains consistent. What distinguishes a Johnson painting is, first, an intense personal fascination with the natural world in all its intimate detail, and second, a sense that such vision brings out the special intimacy of interactions within this natural scene. Johnson's tranquil meditations always study and celebrate the aesthetic harmonies in patterns of color, shape, and texture which link the diverse elements of the landscape, the ecological relations which make each natural element a part of an intricate whole, and also the close interdependence between this natural system and the people who come to it for their livelihood, their recreation, and their spiritual renewal. Emphasizing these harmonies, Johnson's paintings seem intended to serve as the bridge between human viewers and the natural world.

Tracing the life: education, experiences, and associations

While Johnson's paintings leave a record of the intimate details of the natural world in the nineteenth century, the written record about the artist's own life is fragmentary and somewhat contradictory. The most substantial biographical summary about Johnson that was published during his lifetime is found in the 1904 edition of *Lamb's Biographical Dictionary*. In this column-long article on the artist, his birth date is listed as May 10, 1827 in New York City and his parents as David and Eliza, of Dorchester, Massachusetts, and Philadelphia, Pennsylvania, respectively. His father, the article notes, built the country's first mail coaches. Concerning his education in the fine arts, the entry explains that David Johnson was "educated in the public schools, and except for a few lessons with Jasper F. Cropsey at the beginning of his career he received no instruction in art."[2] The entry goes on to say that Johnson married Maria Louise West in 1869, that he was a long-standing member of the National Academy of Design and a founder of the Artist's Fund Society. It continues by listing his most important paintings, the awards he received at the Centennial Exhibition of 1876 and in 1877 at the Massachusetts Charitable Mechanics Association, as well as the fact that the artist's *Scenery on the Housatonic* was exhibited at the Paris Salon of 1877.

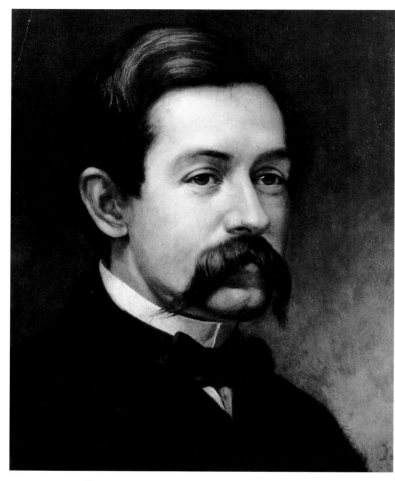

Self-Portrait, 1860. Oil on canvas, 17⅝ x 13⅝ inches. The Arden Collection.

Such a dry biographical summary involves some curious omissions about crucial questions in regard to Johnson's travels and training. For example, the entry does not mention his elder brother, Joseph Hoffman Johnson (1821-1890), or this brother's involvement in the arts, though he painted the portrait of the artist now in the collection of the National Academy of Design.[3] It also does not help to answer the question of whether or not the artist had been to Europe. The brief entries on Johnson in several other biographical dictionaries of American artists categorically state that the artist had never been abroad.[4] Yet, at the end of his life, Johnson owned a number of European paintings,[5] and the descendants of friends of his widow, who purchased many of the artist's drawings, remember being told

that the artist had been to Europe.[6] Also, on the question of Johnson's formal training, all of these biographical sources portray Johnson as an artist who was self-taught (except for his well-known sessions with Jasper Cropsey). But the records of the National Academy of Design also show that a David Johnson registered at the Antique School for two seasons (1845-47),[7] which would mean that he did have some other formal instruction in art.

Vexing questions remain about several other possibly formative experiences in the artist's life. What did Johnson do during the Civil War? The *New York Daily Tribune* reported on May 5, 1861 that several artists had volunteered for duty in the war, including a "D. Johnson."[8] Few dated landscapes from 1861 and 1862 are known; among the small group of portraits done by the artist is a stern likeness of General Winfield Scott, painted in 1861 (Collection of The Pennsylvania Academy of the Fine Arts). But this portrait is based on a Mathew Brady photograph that hung in the photographer's New York studio[9], and so ultimately Johnson's Civil War experiences remain a mystery. A similar lacuna exists in the information about the artist's travels later in the 1860s. John I. H. Baur suggests that the artist might have made an excursion to the American west in 1864.[10]. A view of Twin Lakes in Colorado, now called *Mountain Landscape* (The Anschutz Collection, figure no. 3), which is dated 1865, also gives weight to the theory that Johnson had been in the west, but there is also evidence that the work was painted from a photograph, rather than on the site or from sketches.[11]

Thus, on many crucial points, the basic information about Johnson is surprisingly limited. This problem is exacerbated by somewhat comical confusions between David Johnson, David Claypoole Johnston (1798-1865), a genre painter, and Eastman Johnson (1824-1906), a better-known genre and portrait painter who became an associate of the National Academy of Design at the same time as David Johnson. The styles of the three artists are distinctive, but in short notices, meeting minutes, or reminiscences, it is sometimes difficult to determine if the identification is correct or if the author or editor is mistakenly referring to the wrong artist.

Some of the more solid clues to these questions about David Johnson's travels and experiences are found, very simply, in the titles of his paintings and drawings. Upstate New York is the subject of a great many works. These include views of some of the frequently painted sites in the Hudson River valley, the Catskills, the Adirondacks, Lake George, and the Genesee region, as well as landscapes in places less popular with the prominent painters of the era, such as Broome County near Binghamton and New Berlin in the central part of the state. He also painted in the White Mountains, near the Androscoggin River in Maine, the area around Shelburne in

Vermont, Natural Bridge in Virginia, in the western part of Connecticut, and northern New Jersey. These locations are known from inscriptions on the back of many paintings, where Johnson typically specified the setting, usually the date, and added his signature, along with a very characteristic flourish.

The artist's activities and his travels are also mentioned in eastern newspapers and periodicals in the summary fashion of the era; one learns, for example, from the June 26, 1869 edition of *The Albion* that Johnson "is sketching on the banks of the Hudson, and in September will visit the White Mountains,"[12] and from the June 17, 1871 edition of *The Evening Post* that Johnson is painting a view of Lake George "intended for the collection of Comptroller Connolly."[13] Occasionally, longer notices give brief descriptions of paintings and the opinions of anonymous critics; for example, in 1876 the writer for *The Evening Post's* Fine Arts column commented at length on several of Johnson's paintings and concluded that "Mr. Johnson's studies show great care and earnestness in their execution, and their freshness of color and purity of tone are pleasant reminders of our meadows and forests as seen in nature."[14] In such notices, the words that are used most frequently to provide summary characterizations of Johnson's paintings are "exact" and "transcription" and "close study."

Turning to other sources to flesh out the picture of Johnson's life, one learns from the yearly New York City directories that New York remained home for the artist for most of his life: for all but three years between 1851 and 1904 the directories list the artist's home, and for many years a separate location for his studio.[15] (In 1904, Johnson moved to Walden, New York, where he died in 1908.) New York offered Johnson the possibility of a broad range of artistic contacts. As a member of the National Academy of Design in New York, Johnson must have known many of the established artists of the period; he served on the hanging committee in 1874 and found himself at the center of controversy when he and his fellow committee members decided not to hang two paintings by John LaFarge (1835-1910), a duly elected Academician.[16] He is mentioned briefly in the reminiscences of his fellow artists Benjamin Champney (1817-1907)[17] and Jervis McEntee (1828-1891), who reported that Johnson was the person who found John F. Kensett (1816-1872) dead in his studio;[18] other artists such as John Williamson (1826-1885) and Alfred T. Ordway (1819-1897) are sketched and identified in the artist's drawings.[19]

While on painting expeditions with other artists, and as a tenant of a studio in the Y.M.C.A. building, Johnson may well have participated in discussions about art theory and technique, but he never wrote about art for *The Crayon* or other art periodicals and apparently never published any writings on any topic. On the other hand, he was certainly interested in reading about art; from the library of the National Academy of Design, Johnson signed out a broad range of books—from *DaVinci on Painting* to William Dunlap's *History of the Rise and Progress of The Arts of Design in the United States.*[20]

The most tantalizing glimpse into Johnson's meditations about art and nature comes in an 1878 letter by the artist. Written after the artist's painting *Brook Study at Warwick* (cat. no. 33, cover illustration) was sold in Utica, and addressed to George W. Adams, president of the Utica Art Association, this letter presents Johnson's only known commentary about art, and gives further weight to the emerging sense of him as a literate and thoughtful practicing artist. Johnson writes:

> The Brook Study purchased at your exhibition by Mrs. Williams is an out door study, painted entirely upon the spot and is, as far as I was able to make it so, a literal portrait of the place. I placed my easel there and went to work earnestly to find out how Dame Nature made things, divesting myself of all thoughts of picture or Studio effects. The location of the view is upon a Brook that rises in the mountain two miles west of Warwick, Orange Co. and empties into the Wa-wa-yan-da which flows through Warwick. The inhabitants know the spot well and [it] is frequented by them in pleasure parties. Take it all in all, it is the most delightful ravine I ever came across. The picture was exhibited at the Centennial Exhibition and contributed largely I have no doubt, to gain me an *award of a Medal* for first class art. I am delighted the picture has found so good a resting place, and a pendant to the great Corot, just think of it. Although I see things and put them down diametrically opposite to the great master, I *admire his work immensely.* I admire his delicious gray qualities, faultless compositions etc. and this particular one, which I saw at M. Cottiers here is particularly rich in those qualities of light, silvery light. Please express many thanks to Mrs. Williams...[21]

In distancing himself from "Studio effects," Johnson wants to stress the intimacy of his knowledge both of this specific natural setting and of the history of human associations with this setting. Typically, he has chosen to create a "portrait" of a much frequented place, which the current inhabitants know well, and which still carries the lore of ancient names given by Native Americans. Johnson, too, knows the spot well—his description includes the names of the rivers and the distances to the location; he has not only explored the site but "placed his easel there" to create the painting "out doors" rather than in a distant, indoor studio. At the same time, however, he demonstrates his knowledge of European painting and, in particular, his considered reaction to the work of Jean Baptiste Camille Corot (1796-1875), an important French painter of the Barbizon group. Johnson even goes so far as to suggest that his own work is worthy of

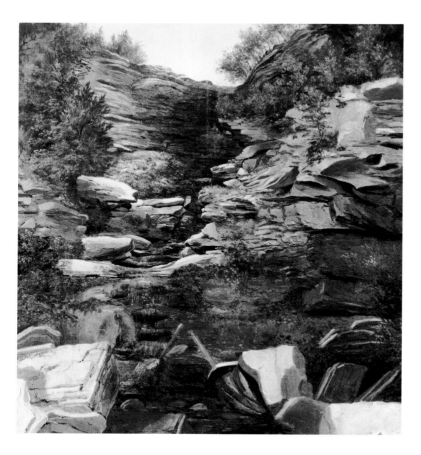

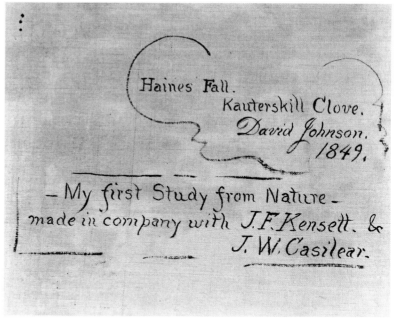

Cat. No. 1 *Haines Falls, Kauterskill Clove,* 1849. Oil on canvas, 16 x 14½ inches. Collection of Marilyn Kerner. Above, back of canvas.

being a "pendant" to a painting by "the great master." Although there is little in *Brook Study at Warwick* which would indicate that Johnson admired Barbizon painting, the American artist's knowledge and admiration of this French style are demonstrated by the incorporation of many Barbizon characteristics in other works from this period and later, despite his assertion here that "I see things and put them down diametrically opposite to the great master."

The career in painting

Because of the scarcity of written information by or about David Johnson, an overall sense of Johnson's career must build primarily upon close study of the visual sources: the most complete survey possible of the paintings and drawings themselves. What are the distinguishing characterics and patterns of development in Johnson's oeuvre?

First, and most simply, Johnson signed his paintings using a distinctive monogram which he drew by painting his two initials, the "D" and the "J," in a single continuous paint stroke. The monogram does not appear on his earliest paintings, but was probably developed in the early 1860s. On occasion, this monogram was also later added to some earlier paintings along with inscriptions on the back of the canvas.[22]

Johnson broadened his interest in subject matter over time, and experimented with different styles in various periods of his long career. In rough outline: the subjects of his early works involve either broad vistas or careful studies of rocky forest interiors, a middle period is characterized by long lake views which are both precisely painted and luminous, while his later paintings are usually more tonal compositions, often with cows or people in the foreground, in which the focus is on a large tree or group of trees. But whether he is working in a style that closely parallels that of Asher B. Durand (1796-1886), Jasper F. Cropsey (1823-1900), John F. Kensett, or French Barbizon art, Johnson never loses his primary concern with topographical and botanical accuracy. Johnson's trees, rocks, and mountains can,

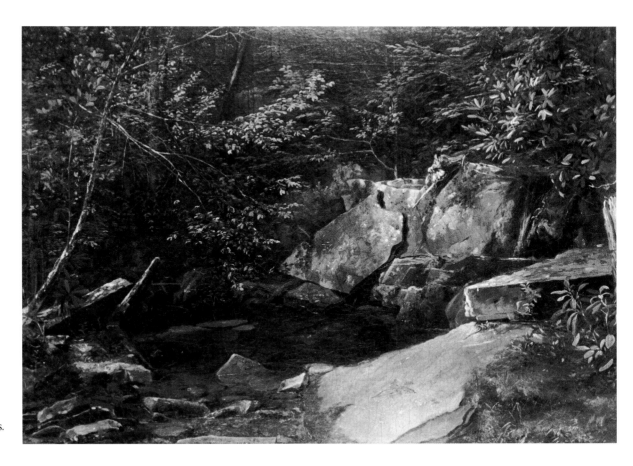

Cat. No. 2 *Fannie Glen, New Jersey,* 1850. Oil on canvas, 17 x 22¾ inches. Anonymous loan.

in most cases, be identified. This is not simply a case of painting the leaves so that they are obviously "maple" or "oak" leaves; Johnson understood the morphology of his trees. For every tree he drew the bark correctly, made the canopy the characteristic shape, and made the angle of the branches to the trunk realistic. Throughout his stylistic evolution, Johnson approached both the individual elements of the world he painted, and the overall processes of growth and change in that world, with a knowing naturalist's eye.

Like many of his contemporaries, Johnson painted works in series. But these series do not simply consist of several small studies leading to a final larger view; they often include several finished paintings of a similar size and subject, dated from successive seasons. Suprisingly few of Johnson's paintings are large-scale; his oeuvre consists mainly of paintings ranging from one to two feet in height and two to three feet in width. But he also seems to have treated some landscape subjects only in a more intimate, small-scale format.

The artist's drawings, many of which relate closely to paintings, were often done on large sheets and highlighted with white, making them finished works in themselves.

Early work: detailing the forest interior

Whether or not Johnson was a self-taught artist, he had already achieved a considerable degree of skill by 1849, when he first exhibited both at the National Academy of Design and the American Art-Union.[23] This was before he studied landscape painting with Jasper Cropsey, in whose account books it is recorded that Johnson paid for lessons in 1850.[24] The painting exhibited at the NAD in 1849 was a *View of the Lower Falls, Genesee River* (present location unknown).[25] A number of prominent artists—among them Thomas Cole (1801-1848), whose 1847 *View on the Genesee River* (Museum of Art, Rhode Island School of Design) had been purchased by the American Art-

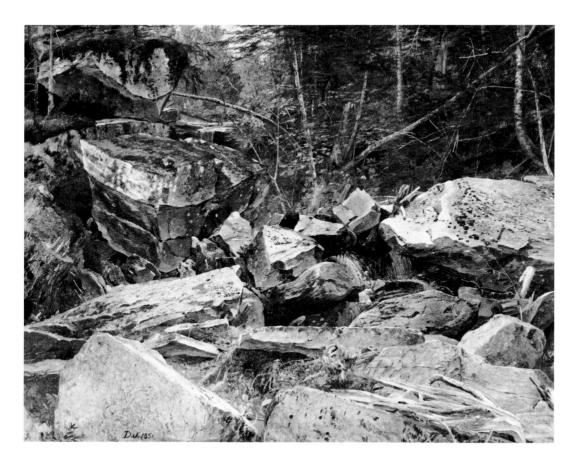

Cat. No. 4 *Forest Rocks,* 1851. Oil on canvas, 17 x 21 inches. The Cleveland Museum of Art, Mr. and Mrs. William H. Marlatt Fund CMA 67.125.

Union in New York, and Frederic Church (1826-1900)—had painted in the Genesee River region. Even if he was, at this point, working and exploring alone, Johnson's very choice of this particular location in upstate New York suggests that he was, at the very least, aware of the work of other American landscape painters. And certainly Johnson did not always work in isolation. Another waterfall painted by Johnson that same year, *Haines Falls, Kauterskill Clove* (cat. no. 1), is inscribed on the verso with the title, date and the inscription: "My first Study from Nature/made in company with J.F. Kensett & J.W. Casilear."[26] The degree of accomplishment evident in the painting suggests either that Johnson had learned his lessons well before ever painting a landscape on site or, perhaps, that he misremembered his own chronology when he later inscribed the information on the back of the canvas. Haines Falls, the second highest waterfall in the Catskill Mountains (160 feet), is here presented by Johnson in a manner that would become characteristic of his style. In this small, almost square, canvas, the height and drama of the dangerous rocky ledges are not emphasized; instead, the main focus here is on the integration of

vegetation, rocks, and the small trickle of water coming over the rim of the falls. Already, Johnson shows himself to be less concerned with verticality or depth than with surface patterning.

The same emphasis on the harmony of the elements of the natural world is apparent in *Fannie Glen, New Jersey* (cat. no. 2), a painting from 1850. In this close-up view of a forest pool, with flat rocks in the foreground that draw the viewer's eye into the painting, the mood conveyed is one of tranquility. At the right, rhododendrons by a cluster of rocks dappled with sunlight seem to define a meditative sitting-place for the viewer; because the background dissolves into a darker forest, the vision is not of a vast expanse, but of an intimate forest interior.

A third early painting of rocks, *Forest Rocks* (cat. no. 4), involves the same type of composition, but this time the subject, according to the inscription on the verso, is a brook in North Conway, New Hampshire. Painted in 1851, this work has many of the qualities of the

Cat. No. 41 *Elizabeth Town,* 1859. Pencil on paper,
15¼ x 10 inches. The Janville Collection.

Catskill and Fannie Glen rock paintings: careful and accurate depiction of the rocks and trees (this time the trees are hemlocks, maples, and yellow birches); large, flat boulders in the foreground; and, despite the more jagged and jumbled arrangement of this interior, a general sense of the location as a pleasant place for human exploration. An elegant drawing of a waterfall in Elizabethtown, New York (cat. no. 41),[27] dated 1859, shows that this type of rock study was of continuing interest to the artist throughout his career.

Such careful delineation of close-up forest scenes has led some critics to associate Johnson with the contemporary Pre-Raphaelite movement in America.[28] The Society for the Advancement of Truth in Art, the formal group organized to promote the ideas articulated by the English essayist John Ruskin in his *Modern Painters,* would certainly have been known to Johnson, since he was acquainted with

artists in the group[29] and would probably have seen their publication, *The New Path.* But this group, which advocated painting that was "true to nature," according to their reading of Ruskin, did not form until after 1860, when Johnson had been painting carefully drawn landscapes for more than ten years. *Modern Painters* was, however, published in America in 1847, at precisely the time that Johnson was beginning his career. As Worthington Whittredge (1820-1910), a painter-comrade of Johnson, noted in his *Autobiography,* Ruskin's book was being read by every American landscape painter at mid-century.[30] It would therefore seem likely that the young Johnson became familiar with Ruskin's writings as soon as they appeared. But Johnson then took the lessons to heart in his own particular fashion, coming to an understanding of Ruskin and reaching conclusions about painting that differed sharply from those of the members of the official Pre-Raphaelite group in America.[31] The paintings of John Henry Hill (1839-1922), Charles Moore (1840-1930), and other artists who were formal members of the Society for the Advancement of Truth in Art are meticulously drawn to show every minute element of the subject, be it forest or still life, in as much detail as possible, creating an effect of hyper-real vision beyond that possible in normal human perception. Johnson's paintings, while detailed and painted with a fine brush stroke, remain closer to actual human vision; they have a focus, a single point to which the eye is drawn. Rather than the high-keyed colors of the Pre-Raphaelite palette, Johnson characteristically tends towards more subdued tonalities; his more obvious sfumato effects render his landscape backgrounds much less crisp or hyper-clear. And while Johnson shared with the American Pre-Raphaelites an emphasis on surface textures—details in the bark, the flower, the leaf or the Ruskinian rock— he was also interested in the structure and the solidity of the objects in his paintings.

Landmarks in the landscape

When Johnson turned to other landscape subjects, in addition to the forest interiors that obviously were of great ongoing interest to him, he continued to work in the same exacting manner. *Old Mill, West Milford, New Jersey* (cat. no. 3), which was painted in 1850, the year in which Johnson studied wtih Jasper Cropsey, presents a precisely rendered view of an abandoned mill. Because of the rising demand for lumber in this period, sawmills had become a common sight, particularly in areas that were undergoing the transition from wilderness to a more settled existence. Sawmills were a clear sign in the landscape of the encroachment of civilization, as the site for the violent transformation of trees into lumber. In mid-century discussions, they could be interpreted as "emblems of progress and/or symbols of greediness,"[32] but Johnson's portrayal of the mill seems strangely silent in this debate. Johnson's mill scene, though, does define a clearing, a place for human activity in the wilds, and

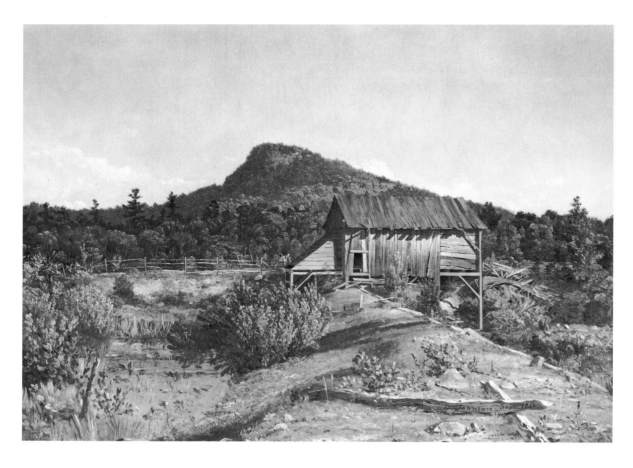

Cat. No. 3 *Old Mill, West Milford, New Jersey,* 1850. Oil on canvas, 17 x 13 inches. The Brooklyn Museum, Gift of Peter A. Leman 08.223.

thus serves as a link between the civilized and natural worlds. And the mill he has chosen for study has been abandoned; this portrayal then stresses tranquil silence over the loud ripping sounds of a busy industry; the mill's own lumber is seen returning to the patterns of a more natural state.

Paintings from the 1850s demonstrate that Johnson continued to expand his horizons, exploring both new places and new types of composition. First, he began the decade with a brief period of formal instruction under Cropsey. It is unclear just why Johnson, who was already an exhibiting artist, decided upon such study, but perhaps the senior artist (though just five years older) could offer the benefit of his broader aesthetic experience, since he had recently returned from Europe. Indeed, from these lessons Johnson seems to have learned one of Cropsey's conventional modes of arranging a pictorial scene, an arrangement based on the European models of Claude Lorrain (1600-1682) and John Constable (1776-1837). This method of composing a picture, in which the view is framed by trees at the left

or right with the middle of the canvas opening to a distant view, reappears in Johnson's oeuvre at various points. *Chocorua Peak, New Hampshire* of 1856 (figure 1) is an excellent example of a painting by Johnson that makes use of this format. The mountain that is the subject of this painting has a distinctly shaped peak that Johnson has been careful to delineate. The large framing pine tree at the right, intended to lead the eye into the painting, is simply added as a pictorial convention rather than in the interest of topographical accuracy—it has been shown to be the same tree that also appears in *Study of a Pine, West Milford, New Jersey* (private collection), a painting that Johnson did while working with Cropsey.[33]

A Study, Bash Bish Falls (cat no. 5) reflects another development of Johnson's earlier interest in the forest interior, now adding people to the setting. This was not the first painting by Johnson to include people—*North Conway, New Hampshire* (1852, Museum of Fine Arts, Boston), for example, has two men in the foreground—but in the waterfall painting Johnson uses these human figures to add an

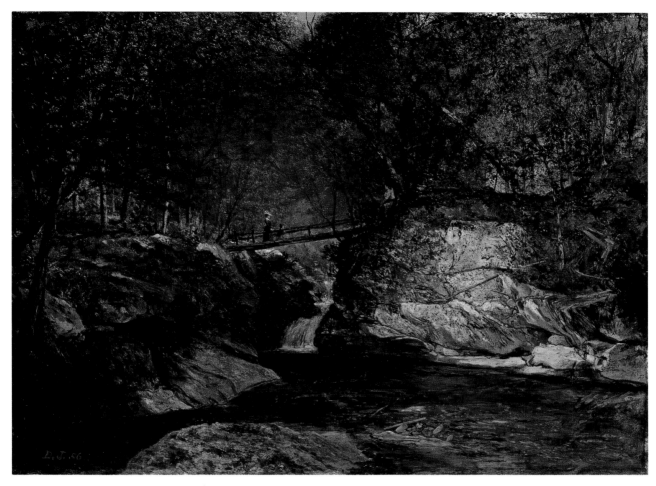

Cat. No. 5 *A Study, Bash Bish Falls,* 1856. Oil on canvas, 15 x 20 inches.
Collection of Mr. and Mrs. David A. McCabe.

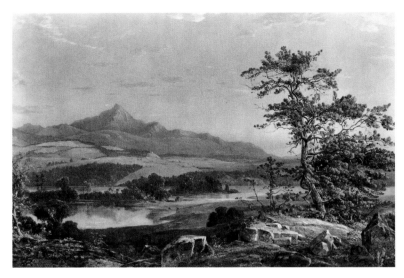

(Fig. 1) *Chocorua Peak, New Hampshire,* 1856. Oil on canvas, 19⅛ x 28¼ inches, inscribed l.r. : DJ [monogram] 1856. Private collection.

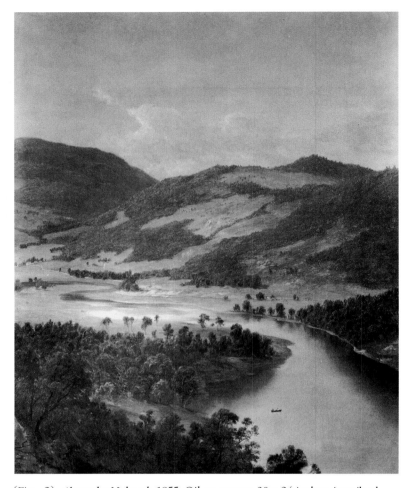

(Fig. 2) *Along the Mohawk,* 1855. Oil on canvas, 30 x 24 inches, inscribed l.l.: DJ [monogram] 1855. Private collection.

implied narrative element. A woman and a child are walking across the bridge over the falls, while a man, mysteriously almost hidden from view, where the bridge meets the high bank at the right, seems to be waiting and observing them. Bash Bish Falls, located in Berkshire County, Massachusetts, is the highest waterfall in the state; in the nineteenth century it was a popular resort area. Characteristically, then, Johnson has chosen as his subject not a wilderness scene but a picnic park; here it is only natural that his painting would include people. Johnson was among many painters who sketched there; John Kensett is also known to have done several Bash Bish Falls views in 1855. There is no longer a bridge at Bash Bish for comparison to this one, but, if we juxtapose Johnson's picture with Kensett's *Bash-bish, South Egremont, Massachusetts* (Museum of Fine Arts, Boston), it becomes clear that Johnson distorted the scale of his treatment here, making the people on the bridge larger than they would be from that viewing distance, and also, at the same time, using a slightly higher vantage point to "tame" the waterfall, making it appear not wilder or more extraordinary but less sublime. In effect, then, the artist here takes a notably dramatic feature in the landscape and gives it a more human scale.

In contrast, when Johnson painted *Along the Mohawk* (figure 2) in 1855, he chose to present a view of the Mohawk River valley in

New York from high on a hillside, thereby emphasizing the change in elevation between the viewer and the river. Here the viewer is given no place to stand. A tiny boat, almost lost in the foreground, only reinforces the idea that it is a long way down to the river. The Mohawk River was of great importance and probably became well known to American audiences both because of its literary association with James Fenimore Cooper's novel, *Drums Along the Mohawk,* and because the Erie Canal was built along it between Troy and Utica. Although a patterning of forest and cleared land on the opposite shore here makes it obvious that this landscape has been altered by man, Johnson gives no recognition to the intrusion of the canal.[34]

22

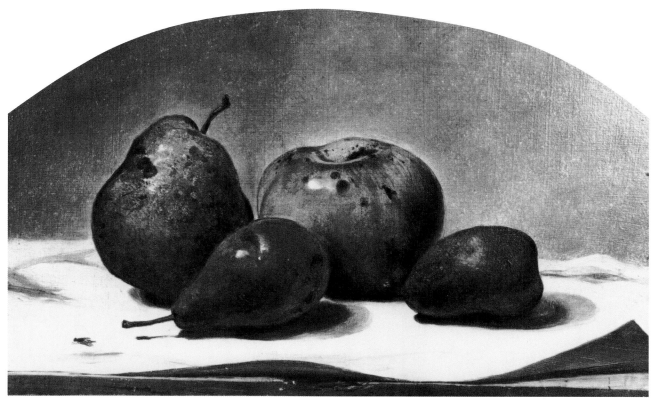

Cat. No. 6 *Three Pears and an Apple,* 1857. Oil on academy board, 11⅜ x 16⅛ inches. Anonymous loan.

The quest for accuracy: still lifes and topographical explorations

Because Johnson was clearly fascinated by the particulars of nature, it is not surprising that he also painted still lifes, which served as his laboratory for subtle, almost microscopic studies of natural objects. *Three Pears and an Apple* (cat. no. 6) depicts three distinctly different varieties of pear, positioned on a cloth along with one apple and even two minutely observed flies (one at the left and one on the apple). The artist was obviously trying to create a *trompe l'oeil* effect: the table below the cloth, visible along the lower edge of the painting, is damaged at the center in a way that makes the viewer wonder if it is the bottom part of the frame that is splintered; the two flies also serve to heighten the realism, while adding a final touch of humor to the painting. The centerpiece fruit are all distinctly drawn, down to the fine blush on the cheek of one pear and the differences, normally noted only by a fruit farmer or a botanical illustrator, in the relative sizes of the various pear species. The painting then becomes a celebration of the wide variety of pears currently flourishing in the American environment.[35] *Apples and Quinces* (cat. no. 7) has sometimes been mistitled *A Dish of Apples,* because the yellow quinces have been mistaken for apples. But the artist goes to great lengths here to stress and study the differences between quinces and apples (these are probably the Northern spy variety, which is the same variety that is shown in the other still life). Although its setting is more conventional (a simple dish), and while there are no flies here, this painting does show the fruit complete with their surface imperfections.[36]

Johnson's interest in the world around him was certainly never wholly confined to "pure" nature or to purely natural elements. Houses, human inhabitants and visitors often dot his pastoral landscapes. In 1860, Johnson became especially interested in bridges, both natural and man-made, as he then began a series of views of the Harlem River Aqueduct and also of Natural Bridge in Virginia. Bridges

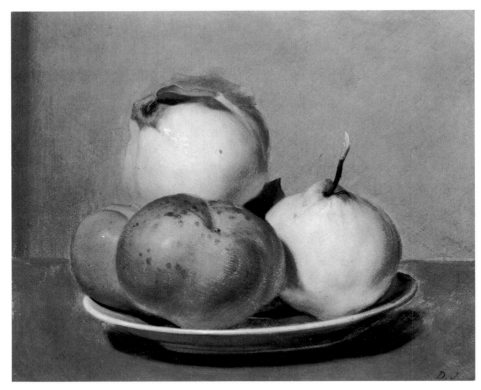

Cat. No. 7 *Apples and Quinces,* c. 1857. Oil on canvas, 10¼ x 12½ inches. Spanierman Gallery, New York.

seem to be the perfect symbolic conveyors for themes central to Johnson; they suggest "bridging" connections between natural and human worlds. The Harlem River Aqueduct, which is also sometimes called the High Bridge, was part of the system built from 1839 to 1842 to bring water from upstate New York to the growing city of New York. Designed by John B. Jervis, the bridge owes an obvious debt in its design to the ancient Roman aqueducts. A small painting, now called *Harlem River Aqueduct* (cat. no. 8), for which there is also a known drawing (cat. no. 42), presents the bridge across the river in precise detail, not as an interruption in the natural order but as an integral part of the river scene. In fact, the bridge serves aesthetically as a linchpin, linking foreground and background, water and land, viewers and vista. *High Bridge* (cat. no. 9), an unusual miniature by the artist, approaches the same subject from the opposite side of the river.[37]

The Natural Bridge in Virginia is a limestone arch more than two hundred feet in height. Because of his earlier rock paintings and apparent interest in geology, it is not surprising that Johnson would

have been drawn to treat this landmark. A well-known tourist destination, the Natural Bridge had fascinated eighteenth century European tourists; there were numerous visual depictions of it, as well as rhapsodic travelers' accounts, by both Europeans and Americans.[38] Johnson recorded several views of the arch from Cedar Creek (which runs below and through the bridge), exaggerating the scale and vertical thrust of the bridge. But he also painted a very different view of the bridge from several miles away (cat. no. 10). From this latter vantage point, it is the horizontal curve of the arch of the bridge, in its connection with the rolling hills, that is accented. This distant view brings out the geometry or architecture inherent in nature; Natural Bridge here comes to resemble a man-made structure that has become overgrown with vegetation, not unlike the ruin of a Roman aqueduct.

Was Johnson perhaps regretting that he had not been to Italy? Were these paintings perhaps an attempt to show that America could offer arches or ruins which were just as picturesque as those found abroad? If Johnson's motivations for painting both Natural Bridge and

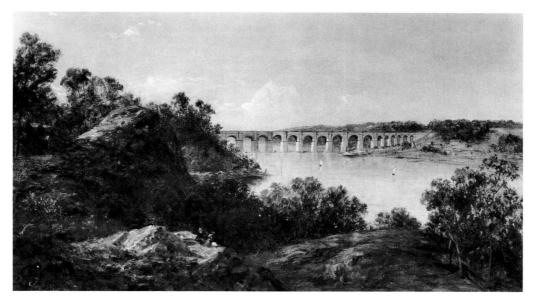

Cat. No. 8 *Harlem River Aqueduct,* 1860. Oil on canvas, 7¾ x 13 inches.
Hirschl & Adler Galleries, Inc., New York.

the Harlem River Aqueduct were nationalistic, it is surprising there are no known paintings by him of the immense Starrucca Viaduct in Lanesboro, Pennsylvania, possibly the best-known bridge of the era and the subject of numerous paintings, prints, and travel-guide descriptions. The viaduct, constructed in 1848 as part of the railroad line from Deposit, Pennsylvania, to Binghamton, New York, was an

Cat. No. 42 *Harlem River Aqueduct,* c. 1860. Pencil on paper, 12¼ x 18⅛ inches. Paul Worman Fine Art, New York.

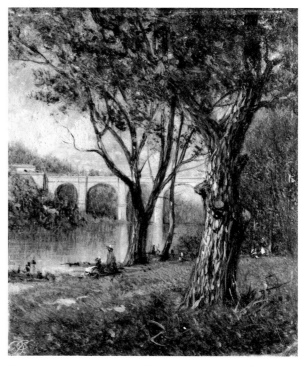

Cat. No. 9 *High Bridge,* c. 1860. Oil on paper, 5 x 4 inches. Collection of Jeffrey and Dana Cooley.

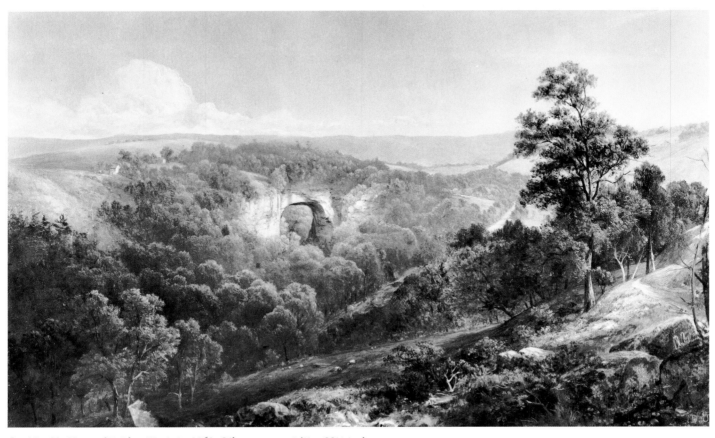

Cat. No. 10 *Natural Bridge, Virginia,* 1860. Oil on canvas, 14½ x 22¼ inches.
Reynolda House, Museum of American Art.

impressive engineering feat consisting of seventeen arches.[39] Jasper Cropsey's *Starrucca Viaduct, Pennsylvania* (Toledo Museum of Art), a painting of 1865 for which he began sketches in 1853,[40] uses very much the same compositional scheme as *Harlem River, Aqueduct,* and may even be the model for Johnson's bridge painting. In each work, spectators survey the view from a high vantage point in the foreground on the left side of the composition, and the bridge appears in the middle ground.

Several other paintings of this era do not celebrate notable landmarks, grand vistas or great mountains, but more modestly seek to convey information about a quiet corner of landscape, often the edge of a forest. At least four paintings from 1863 document a visit to Tamworth, New Hampshire. Located about ten miles north of Lake Winnipesaukee and about five miles south of Mount Chocorua, the

township of Tamworth is not far from many of the popular painting locations then frequented by artists. But Johnson's Tamworth series (cat. no. 11 and 12) offers neither broad landscape vistas nor closed-in forest interiors; these works take trees and foreground vegetation by a clearing as the primary objects of study. Like the fruit in his still life paintings, the forest details here are distinguished with great attention to their specific species, their characteristic branches and bark, and even to their slightly different hues of green. One painting, *Study at Tamworth, New Hampshire,* 1863 (cat. no. 12) records a remnant of a characteristic New England stone wall, which serves to document that the land, now apparently returning to a more natural state, was once fenced off for pasture or cultivation. At these edges of forest or field, Johnson captures transitional moments when the distinction between forest and field is blurred. Although Johnson may have used elements from these paintings in later more obviously

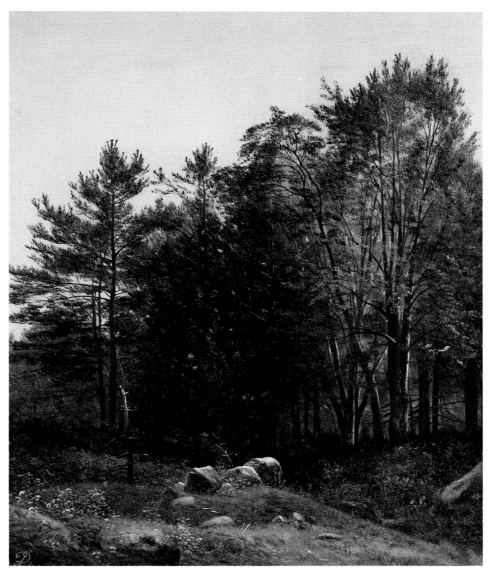

Cat. No. 11 *A Study near Tamworth, New Hampshire,* 1863. Oil on canvas, 16½ x 13¾ inches. D. Wigmore Fine Art, Inc., New York

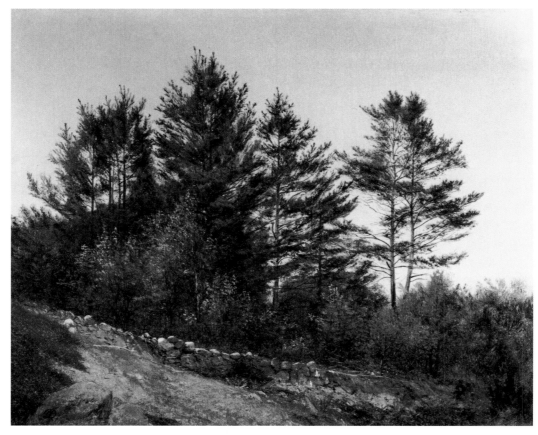

Cat. No. 12 *Study at Tamworth, New Hampshire,* 1863. Oil on canvas, 13⅝ x 16¾ inches. Kenneth Lux Gallery, New York.

composed views, they were not preparatory studies; two Tamworth paintings, both called *Study at Tamworth,* were exhibited at the National Academy of Design in 1865 and 1866.

In the same year, however, Johnson painted *Young Elms* (cat. no. 13), a much more composed tree study with a couple seated on a log before a background of elms. Like the trees in the Tamworth paintings, the elms here are finely drawn, but the addition of the couple in the lower left section of the painting adds a narrative element—one is led to wonder about the subject of their discussion—to a scene that is otherwise simply a view of trees.

Lake vistas

In the mid-1860s, Johnson began to paint the first of many pictures of mountains and lakes in what became for him a set compositional format. *Eagle Cliff, Franconia Notch, New Hampshire* (cat. no. 14), signed with a monogram and the date 1864, is one of the earliest of the paintings using this format: a placid lake in the foreground, a cluster of rocks with small fallen trees in the lower corner of the composition, and a steeply-rising hillside in the background. Frequently, as in this painting, Johnson includes people in a rowboat on the lake. The brushstrokes in these paintings are almost invisible and the emphasis is on the reflective tranquility of the sunlit scene—here the vision seems timeless, with no movement, no wind, and transparent light—as is often found in other mid-century landscape paintings that have been described in recent years as "Luminist" works. Eagle Cliff, a mountain in Franconia, New

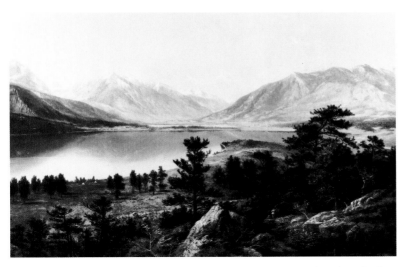

(Fig. 3) *Mountain Landscape,* 1865. Oil on canvas, 20 x 30 inches, inscribed l.r.: DJ [monogram] 1865. The Anschutz Collection.

Hampshire, is here seen from the southwest with Profile Lake in the foreground. Again, Johnson demonstrates his interest in portraying the landscape with a careful eye for botanical detail and a fascination with the interactions between humans and their environment. The trees on the hillside are drawn so that the taller white pines are clearly delineated and stand out from the dominant hardwoods. The mountain slope is painted with striations traversing it; these lines seem to record a history of human impact on this forest, as they mark the skids which were cleared by loggers, who used them to transport cut trees off the hillside.

Johnson's 1867 painting *Echo Lake, New Hampshire* (cat no. 16) is a composition in the same mode; it again centers on Eagle Cliff, this time seen from across a different lake, with Mount Lafayette and Mount Lincoln in the background. Here, numerous tree trunks are visible on the nearby mountain slope; these are either dead trunks remaining after a fire or white birch trees which have light colored trunks that are visible from a distance.[41] The farther slope is mottled by a pattern of breaks in the forest canopy. Such texturing of the hillsides is one of Johnson's primary interests here. In both of these lake vistas of Eagle Cliff, as well as in many compositions of this type, the rocks and small fallen trees in the foreground appear almost as stock characteristics; one suspects that these elements, unlike the far hillsides, were not necessarily part of the actual view, but were instead taken from the artist's own archive of tree and rock sketches. Indeed, a preparatory drawing for *Eagle Cliff* (collection of the Robert Hull Fleming Museum) shows how the artist drew the hillside with marked

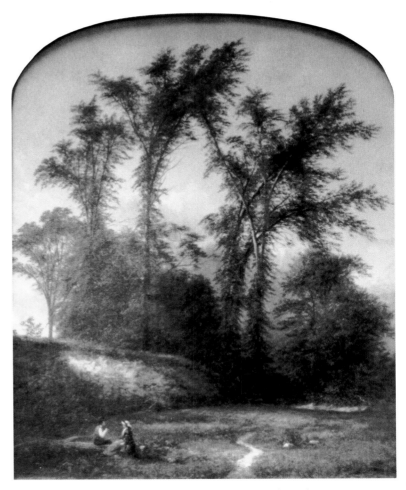

Cat. No. 13 *Young Elms,* 1863. Oil on canvas, 17½ x 14½ inches. Private collection.

attention to detail, while the foreground trees and rocks are only roughly sketched—and here they are positioned on the right side of the composition, rather than on the left, as they were in the final painting.[42]

Mountain Landscape (figure no. 3), a painting from 1865, develops yet another variation on this same type of lake vista composition. Because of the presence of two tents (which strongly resemble Native American teepees) in the foreground of this work, John I.H. Baur theorized that the painting is actually a view of a western locale.[43] This theory has proven to be correct. When compared with photographs of the Upper Twin Lakes in Colorado, it is apparent that Johnson's painting does indeed depict a Rocky Mountain scene rather than a New Hampshire one.[44] Seen from a rise

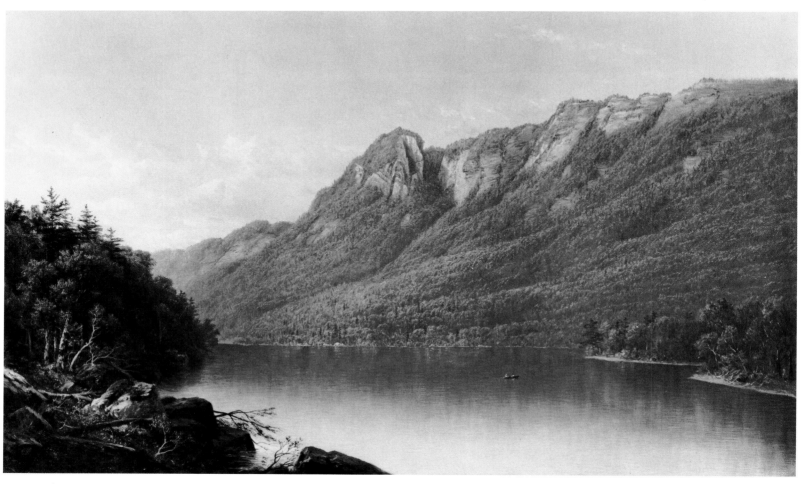

Cat. No. 14 *Eagle Cliff, Franconia Notch, New Hampshire,* 1864. Oil on canvas, 27¼ x 44¼ inches. Amon Carter Museum, Fort Worth.

above a lake in the middle ground, the mountains in this view appear to rise distinctly from one another, unlike many of the New Hampshire mountains which, when seen from a distance, are obviously connected by ridges. But many details of the artist's depiction of the location are odd; the central mountain bears a strong resemblance to Mount Washington, as it is seen in works such as Johnson's *North Conway, New Hampshire* (Museum of Fine Arts, Boston).[45] The pine trees, which in Colorado would most likely be lodgepole pine, rather than the white pine common in New Hampshire, are well-drawn but lack the clearly noted morphology which is so characteristic in most of Johnson's paintings. In effect, he seems in this case to be painting the outlines of a Colorado landscape as if the mountains and the vegetation there were very similar to those

in sites that Johnson knew in New Hampshire. The fact that this is the only Johnson painting of a western subject that is known today suggests that this work was painted from a photograph, rather than as a document of an actual trip west. Because Johnson is known to have painted portraits from photographs, it does not seem unlikely that he also would have used photographs as aids to depicting the landscape, of Colorado or even of eastern locations. By the 1860s Twin Lakes had been photographed, and views of the site were readily available in the east, both in the form of published single photographs and in stereo views.[46] Had Johnson had a copy of such a photograph and perhaps a written description of the location, he might very well have attempted to paint a Twin Lakes view without having seen the site firsthand.

30

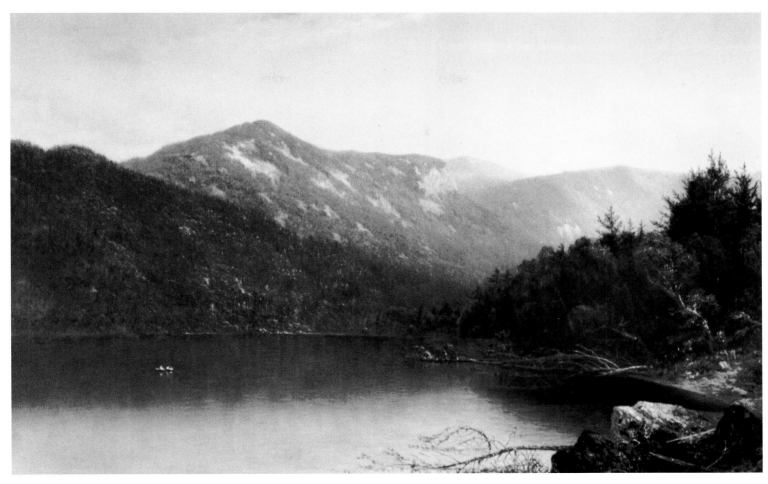

Cat. No. 16 *Echo Lake, New Hampshire,* 1867. Oil on canvas, 30 x 40 inches.
Private collection, New Jersey.

If he probably did not visit the site of this western painting, Johnson certainly did make a mid-1860s excursion to Maine, and produced several views of the Androscoggin River valley. The paintings of this locale vary in subject, emphasis, and size, but they all build upon the perceptual data of an actual visit. *Scene at Bethel, Maine* (cat. no. 15), a river scene with mountains in the background and two men conversing by a gate in the middle ground, again recalls the type of composition modeled upon the paintings of Cropsey. On the side of the mountains, the pattern of cleared land and forest is carefully delineated; it is obvious that this valley is not remote land used only for logging but a settled area; two church steeples are visible at the right. The large tree at the left which frames the painting (according to convention) is likely another stock item from Johnson's

sketchbooks; but the specificity of the contours of the hills and the patterning of the land reflect the type of detail that was of special interest to the artist. The sky in the painting, with dark, threatening clouds at the right—above a blasted tree—while it is bright and clear at the left, suggests connections with the tradition of the earlier, more dramatic paintings of Thomas Cole, such as his *View from Mount Holyoke, Northampton, Massachusetts, after a Thunderstorm (The Oxbow)* (The Metropolitan Museum of Art) of 1836, with its overview of a landscape starkly divided between a dark cloud over a blasted tree in the foreground and bright sky over the civilized farmland below. But in *Scene at Bethel, Maine* the contrasts are less pronounced and the more gradual transitions—dark to light, foreground to background, wild to settled—suggest harmonies rather

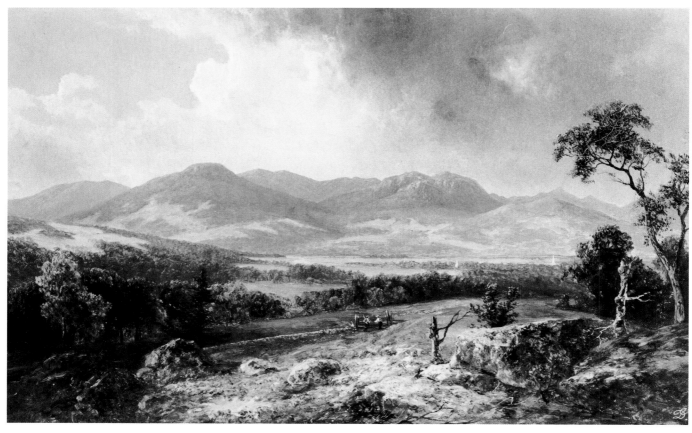

Cat. No. 15 *Scene at Bethel, Maine,* 1866. Oil on canvas, 14 x 22 inches.
Private collection.

than a battle of opposites. The effect is more beautiful than sublime, a pleasing presentation of a landscape rather than a thinly disguised lesson in aesthetic theory.[47]

Another theory view of the Androscoggin River Valley, *Androscoggin River* (cat. no. 21) from 1869, differs from the earlier view of the valley in that it avoids obvious painterly devices, such as trees which frame the composition and dramatic clouds which give the painting stylized contrasts and a composed quality. Thinly painted, this composition presents the river simply as one element in the complex valley system, rather than making it the central focus of the painting. But the consistent element in both Androscoggin paintings is the interest in the patterning of the vegetation and the contours of the distant mountains.

For the Ruskinians of *The New Path,* the Journal of the Society for the Advancement of Truth in Art, a "study" (as the second painting is titled on the verso) was the specific term given to a painting which was a copy directly from nature.[48] Was Johnson here adhering to this idea, and can we regard his paintings which are inscribed as "studies" as exact transcriptions of actual places?[49] Perhaps, but one is more inclined to accept that a painting is intended to be topographically accurate for other reasons as well: for example, if the foreground is not constructed of repetitions of the same trees and rocks that one finds in several Johnson works.

In his quest for this sort of topographical accuracy, Johnson, at times, went so far as to label the mountains by name within a drawing. *White Mountains from Lancaster, New Hampshire* (cat. no. 43), for example, has the names of the mountains depicted written along its bottom edge: Mt. Madison, Mt. Adams, Mt. Jefferson, Mt.

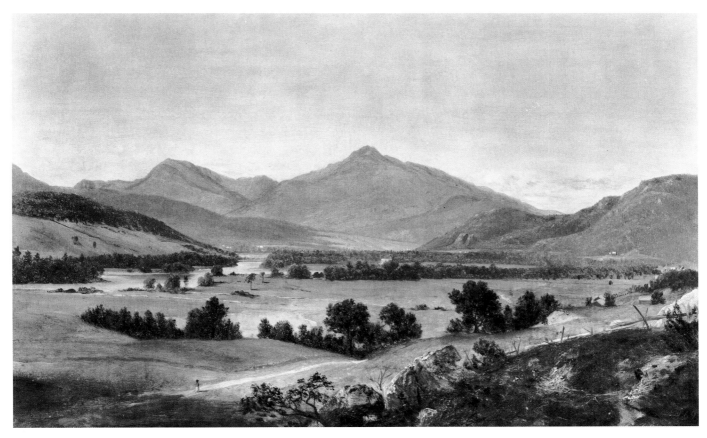

Cat. No. 21 *Androscoggin River,* 1869. Oil on canvas, 14 x 22 inches.
Private collection. Courtesy, Berry-Hill Galleries, New York.

Washington, Mt. Monroe, Mt. Clinton, Mt. Pleasant. Another undated "study," probably from the same period, *Study, Franconia Mountains from West Campton, New Hampshire* (cat. no. 19), has been shown most likely to be an accurate record of the particular place noted so carefully in the title.[50] But, of course, even this literal view is not simply a document, the equivalent of a photograph taken by geographical surveyors. Here Johnson selects the perspective so that his carefully planned composition centers upon a slightly arched grove of trees that balances the view and serves as the point of transition—the bridge—between the sloping foreground and the meandering river's valley, as well as between the left and right hand sides of the painting. A large tree in the foreground (again probably copied from a sketchbook) leans into the picture from the left, while the Pemigewasset River curves in from the lower right corner, so that the viewer's eye is drawn in from both sides of the canvas. In another river view from this period, *The Connecticut River at North Littleton,*

New Hampshire (cat. no. 20), Johnson selects his perspective so as to achieve a similar compositional coherence and balance. The overall pattern of light and dark patches here is anchored by a large central tree, while the thrust in depth is organized around a snaking diagonal line of darker trees which moves from right to left and leads back through the middle ground of the painting.

Experiments in composition

But Johnson's paintings from the 1860s were not limited to these rather straightforward long views of pastoral landscapes. He also experimented with a more ambitious extension of this basic compositional format, replacing the standard foreground tree with a large fallen birch tree in extreme close-up and making this, rather than the background hillside, the central focus of the work. *A Study near Lancaster, New Hampshire* (cat. no. 17) places one such tree,

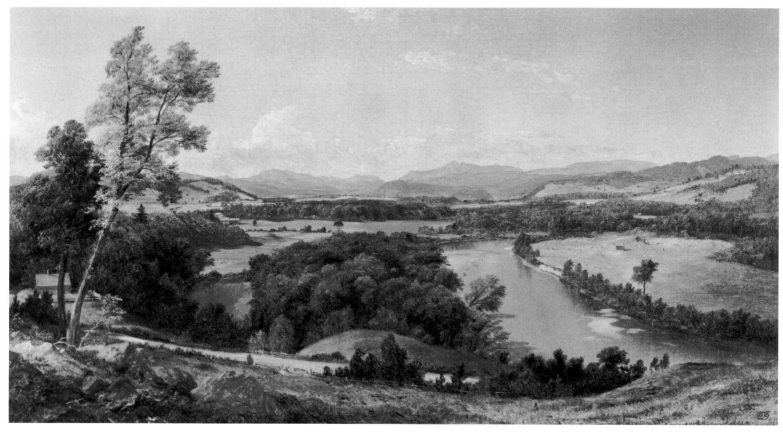

Cat. No. 19 *Study, Franconia Mountains from West Campton, New Hampshire,* c. 1867. Oil on canvas, 14½ x 26 inches. Wadsworth Atheneum, Hartford. Bequest of Mrs. Clara Hinton Gould.

which appears to have been blasted from its roots rather than cut down, before a hillside with a view of a valley beyond and distant mountains.[51] The paint in this work is not applied evenly to the canvas; the birch tree is much more finished than the background landscape. This painting seems, then, to attempt to reconcile two disparate visions: on the one hand, a still life perspective of a paper birch tree, with a small spruce, several ferns by rocks, and other carefully drawn plants, and on the other hand, a distant view of the surrounding landscape. An even more unusual experiment in composition comes in the undated painting *Study of a Cedar* (cat. no. 18), in which the tree is viewed from the ground up but on a diagonal, so that only the sky is visible beyond the tree. This tree appears to be weathered but sturdy; although its bark is separating from the trunk at the base, its solid roots suggest long life. With its upper branches growing in all directions, two of the tree's more

substantial limbs rise up directly on the vertical, so that the strong diagonal thrust of the trunk is counteracted. Although this painting treats only one object, the tree is seen to contain in itself a dynamic tension between balanced forces.[52]

The 1860s were a productive period for the artist; in addition to the New Hampshire and Maine vistas and tree studies, Johnson explored New York state sites in both large and small canvases. Two of the largest paintings in his oeuvre, *View from New Windsor, Hudson River* (cat. no. 22) and *Hudson River from Fort Montgomery* (cat. no. 24) are dated 1869 and 1870, respectively. But the difference in the scale of these paintings did not lead the artist to develop a wholly different type of pictorial composition; looking at just a photograph of either of these paintings, or of a third large Hudson view, *West Point from Fort Putnam* (1867, private collection), one

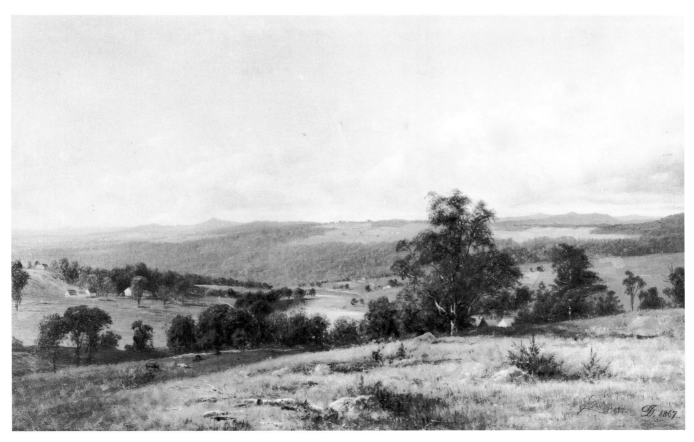

Cat. No. 20 *The Connecticut River at North Littleton, New Hampshire,* 1867.
Oil on canvas, 14 x 22 inches. Private collection.

notes immediately the obvious similarities to the basic form of the smaller-scaled New Hampshire views. Unlike the large landscapes of Cropsey, Church, or Cole, Johnson's paintings on a grand scale do not center upon the theatrical spectacle of sublime sunsets, waterfalls, cloud effects, high mountains on other unusual natural phenomena. They are simply larger versions of the pastoral landscapes one sees in his smaller works. This made Johnson's task in many ways more difficult than that of his contemporaries: his problem was to present a view of a calm, peaceful river valley in such a way that it will nonetheless still attract the viewer's sustained interest. Both of these paintings offer highly successful resolutions of this problem. The selected view, in each case looking down from a hillside over the valley and the Hudson River, is dotted with intriguing details which reward the patient viewer's active eye: sheep to count, stone walls to follow, people walking on paths, a train discernable in the distance, and overall an attractive patchwork pattern of trees and pastureland.

These are not the type of paintings for which the public would buy tickets, gasping as the work was first dramatically revealed from behind its curtain. These works offer slow, leisurely enjoyment, rather than a sudden thrill; the light and color here are subdued, not ecstatically heightened; these visions are anchored by the strong horizontal of rounded background mountains, rather than rising with craggy, misty peaks into infinite space.

At the same time, Johnson also did smaller Hudson River views, such as *A Hudson River Reminiscence* (cat. no. 25). The stretcher of this painting notes the location, "Constitution Island," while the formal title, presumably added later, is inscribed on the back of the canvas. Just north of West Point, steep-sided Constitution Island juts out into the Hudson River. When this view is considered along with the many other Hudson River views from this period, such as *Mouth of the Moodna on the Hudson,* now known only from a print (cat. no. 23), it

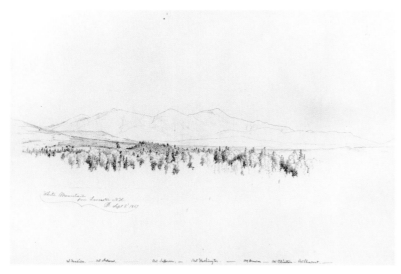

Cat. No. 43 *White Mountains from Lancaster, New Hampshire,* 1867. Pencil on paper, 12¾ x 18 inches. Paul Worman Fine Art, New York.

appears as if Johnson is presenting a painted traveler's log of sites along the river. Each of these three compositions presents a different perspective on the Hudson valley: a narrow river passage, a boathouse in a pastoral setting, and a rocky waterfall near the river. Works of this sort seem to have given Johnson some contemporary reputation as a recorder of the Hudson River in all its variety; *Mouth of the Moodna on the Hudson,* for example, was included in *Picturesque America* (D. Appleton and Company, 1872) a widely-distributed two-volume book, edited by the renowned poet William Cullen Bryant, which presented a celebratory anthology of "the mountains, rivers, lakes, forests, water-falls, shores, cañons [sic], valleys, cities and other picturesque features" of the United States.

Transcribing Lake George

Given Johnson's strong interest in the tranquil side of nature, it is not surprising that he would be drawn to Lake George, New York, as a place to paint. The area around this quiet, picturesque lake, just south of the Adirondack Mountains, has a long and colorful history. In the eighteenth century, it was the site of crucial battles — both in the French and Indian War and in the Revolutionary War. James Fenimore Cooper's popular novel of 1826, *The Last of the Mohicans,* was set in the area, and the public's fascination with this novel was one of the reasons that the region developed in mid-century from a mysterious forested wilderness inhabited by native Americans into a fashionable destination for tourists.

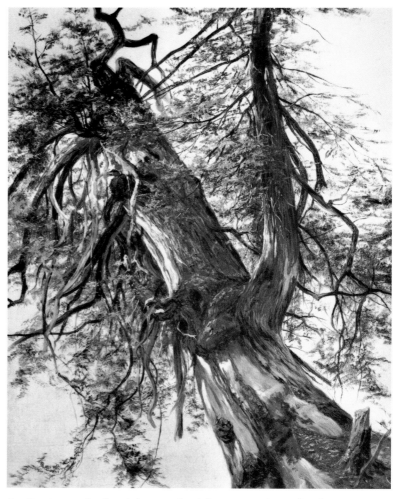

Cat. No. 18 *Study of a Cedar,* c. 1867. Oil on canvas, 20 x 14 inches. Montgomery Gallery

The topography of the Lake George region includes many high hills which rise abruptly from the lakeshore. Thus, after the area was logged, it was found to be unsuitable for the development of large industry, farms, or new towns of any size; there was simply not enough flat land at the shoreline to accommodate any of these uses.[53] But the dramatic beauty of the hills rising precipitously out of the still water, and the multiple islands dotting the interior of the lake, made it an ideal place for summer visitors who came up the Hudson River by steamboat and railroad from New York City.

Johnson's paintings and drawings record the mid-century Lake George, not an inaccessible wilderness but a serene vacation spot, rich

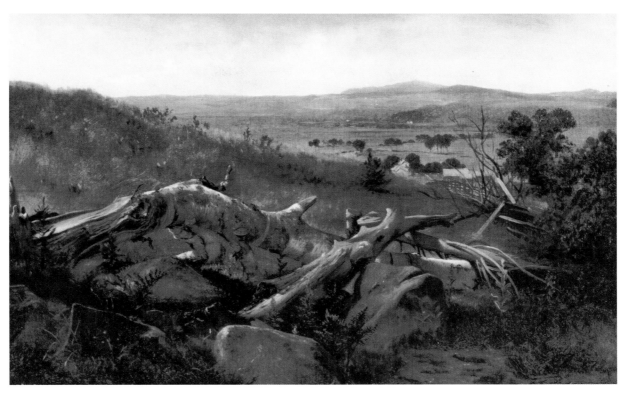

Cat. No. 17 *A Study near Lancaster, New Hampshire,* 1867. Oil on canvas,
13 x 22 inches. Collection of Mr. and Mrs. David A. McCabe.

with natural beauty — in the artist's eyes, the lake itself seems to have an innate elegance. The Lake George scenes were largely painted throughout the 1870s, an era when numbers of grand hotels were operating in the towns of Lake George, Bolton's Landing, and at other points of interest, such as Roger's Slide and Shelving Rock.[54] While many of Johnson's works depict the views from these resort areas, though, he was careful to show the lakeshore unmarred by man-made structures. Boating parties are frequently seen on the lake, as in *Boating on Lake George* (cat. no. 26) or *Lake George Looking North from Tongue Mountain Shore* (cat. no. 32), in small boats drawn with exquisite detail.[55] But the hotels, the sawmills, and any other structures that might seem to intrude upon the pristine shoreline are scrupulously avoided. An occasional steamship can be found in the middle distance on the lake, but it is always far enough away so as to appear no more disturbing to the environment than a rowboat. These boats themselves, though, always subtly suggest a human presence here; they are the means of linking viewers and landscape. In *Study of Nature, Dresden, Lake George* (cat. no. 27), the boat which lies vacant on the shore in the foreground is not presented as abandoned or ruined but simply as the means by which the woman seated down the shore, and presumably the artist as well, will later return to their resort hotel. The obvious market for these paintings would have been the tourists themselves, who would have bought them for their city homes as souvenirs of intimately known and cherished outdoor spots.

By the 1870s, Johnson's technique was tight and controlled; rich colors and evocative compositional structures, in combination with finely honed realistic detail, place his Lake George paintings among his finest. The minute, almost invisible strokes with a fine brush create an effect of Luminist transparency; forgetting the painterly surface and the painter's subjectivity, viewers are drawn into a heightened vision which seems unmediated — a transcendental mode of seeing. The light in the Lake George paintings is almost uniformly even, conveying a mood of serenity. Many of these works are built upon a similar compositional format: rounded hills closing off the vista in the background, shoreline trees and rock formations in the middle ground at the left and/or right, and an open expanse of water in the foreground.

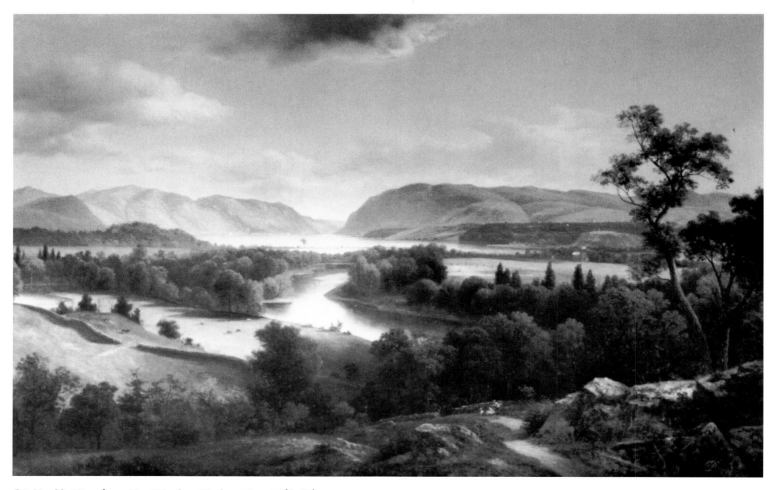

Cat. No. 22 *View from New Windsor, Hudson River,* 1869. Oil on canvas,
38 x 60½ inches. Collection of Elizabeth and Robert Sincerbeaux.

Harbor Island, Lake George (cat. no. 28) depicts a location near Mount Elephant that Johnson painted several times over several years.[56] This version, a hushed, intimate view of the passage between two islands, gives less a sense of a large lake than of a closed-in pond; as the title implies, this is a "harbor," a haven which is shaded, secluded, and safe. The markedly symmetrical composition adds to the feeling of meditative composure: two high trees frame the view, and the small rock outcroppings in the foreground right and middle-ground left echo the curved top of the mountain in the background, balancing each other on either side of the central summit.

A drawing closely related to the painting (cat. no.45) again demonstrates the artist's careful study of the actual trees specific to this site; the pencil study, however, is from a slightly different angle so that the view of the trees and the mountain is not precisely the same. *Harbor Island, Lake George,* apparently benefiting from many such pencil studies, records the characteristic leaves, bark, and growth pattern of each tree, giving the forest depicted here a dense, detailed texture.

Another Lake George site that was the subject of numerous paintings and drawings is Buck Mountain. *Buck Mountain, Lake George* (cat. no. 29) pictures the lake with no evidence of human inhabitants. Both formally and thematically, this work builds out of the contrast between foreground and background. While most of the canvas is thinly painted with very fine strokes of color, the rocks at the lower right corner are drawn with a much coarser paint stroke. Though the primary focus here is clearly on the luminous lake surface in the middle ground, which seems to open a transparent window on the world, the looser style in the treatment of the rocks calls attention to itself as a painted surface. The basic contrast here is between the translucent, unruffled water and the densely textured rock masses in the foreground; that small, rocky shoreline offers the viewer his only sitting place, but the viewer's eye is sent out on a groundless voyage of reflection on the waters beyond.

Landmarks of a career

During the 1870s, Johnson also spent time in Orange County, New York, north of New York City on the east side of the Hudson River. In 1866, Jasper Cropsey had bought land in Warwick, and between 1869 and 1884 spent his summers at "Aladdin," the home and studio he designed and built there.[57] The first of Johnson's paintings of the area seem to date from the early 1870s, which suggests that Johnson's interest in painting the area began when Cropsey built "Aladdin." Two versions of a view from a high point in Warwick looking east to the Hudson River offer an instructive comparison of works from this period; the unfinished painting *Near*

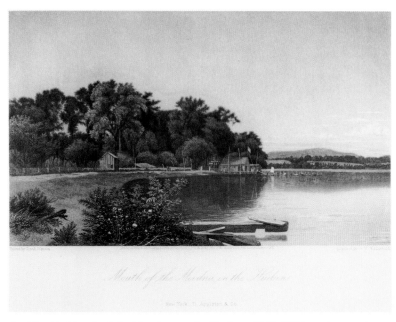

Cat. No. 44 *Mouth of the Moodna on the Hudson,* 1869. 1870 steel engraving on paper by G.W. Wellstood after an 1869 painting by David Johnson, 5¹/₁₆ x 8 inches (plate). Private collection.

Warwick, New York (cat. no. 30) depicts a generalized patchwork pattern of trees and open land reaching to the river in the background, while in a second painting, *Study near Warwick, New York* (cat. no. 31), the trees are drawn with much more attention to the details of the individual canopies, and the stronger sunlight from the left side creates sharper contrasts of light and dark — the shadows and even the numerous cumulus clouds here are clearly defined. In the second, more stylized painting, the artist is attempting to draw attention to the variation in the scene: the different species of trees, some pointed and others rounded (many of them recalling those in long views by John Constable), the wooden fences merging with planted hedges, the various houses, and so on.

In this era, Johnson also returned to the subject of still life painting. *Sketch of Apple Blossoms with May Flowers* (cat. no. 34) was titled, signed, and dated May 27, 1873. Presumably this painting is a work that the artist signed at the time it was painted, and not inscribed later, from memory.[58] Unlike the fruit in the earlier *Apples and Quinces* and *Three Pears and an Apple,* which are displayed on a table, these flowers float on a brown background, neither in a vase nor on a branch.(Both of these flowers blossom on trees: the apple obviously on the fruit tree, and the "may flowers" on the rhododendron.) Also, unlike the earlier fruit still lifes, this painting pictures blossoms which

39

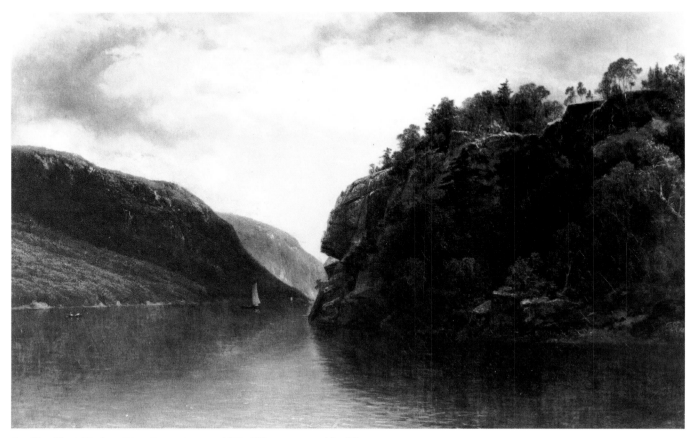

Cat. No. 25 *A Hudson River Reminiscence,* 1870. Oil on canvas, 14 x 22 inches. Collection of Benjamin C. Buerk.

are perfect specimens, with no evidence of any blemishes. Johnson apparently was fascinated by the possibility of a perfect, delicate natural beauty inherent in the blossoms of commonly cultivated trees as well as by the more rugged beauty of rocks and forest trees.

Johnson's most celebrated painting, *Brook Study at Warwick* (cat. no. 33), was, as the artist's letter quoted above relates, painted in a picnicking area near Warwick.[59] Like *Highland Falls, West Point* and the early painting *Forest Rocks,* this work presents a forest niche with such a precise paint stroke that, when reproduced in black and white, it is often mistaken for a photograph. Of course, in some ways, this painting is successful as a naturalist's document. Here Johnson celebrates and takes to new heights his virtuoso ability to present geological formations and tree species with astonishing accuracy. Yet finally the effect is far from that of an illustration for an ecology textbook. Here, the subtle gradations of hue in the foliage, the

highlights of color in the flowers emerging from a dark background of brown and green, and the textural contrasts between the boulders, the moss, and the surrounding hemlock trees reveal that the artist had mastered the ability to develop a richness both of naturalistic detail and of aesthetic effect. Although this dark forest interior is presented as nearly untouched by man — one tree stump in the lower left is the only evidence of human alteration of the landscape — it is not a fearful wild place, but one made inviting by soft contrasts of warm colors. As the artist noted in his letter about this painting, the brook at Warwick was frequented by "pleasure parties."[60] The mossy rocks by this quiet, closed-in pool indeed suggest that it might be the perfect setting for a picnic.

Not surprisingly, *Brook Study at Warwick* did not go unnoticed. Johnson exhibited the painting, along with two others, *Old Man of the Mountains* (figure no. 4) and *Scenery on the Housatonic,* at the

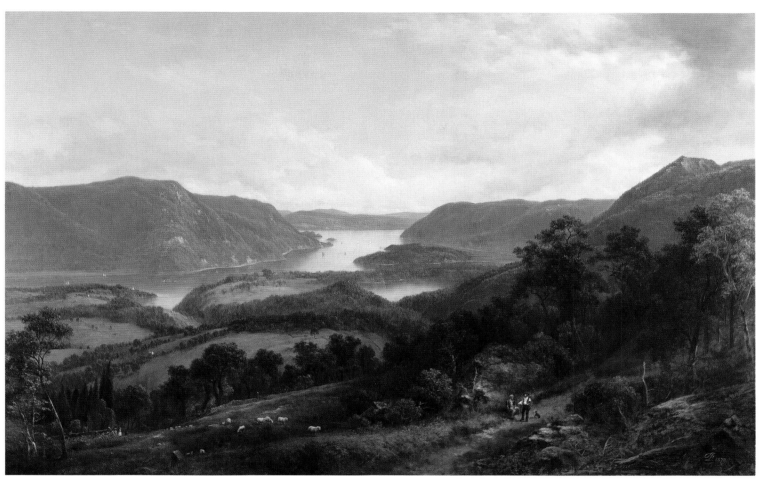

Cat. No. 24 *Hudson River from Fort Montgomery,* 1870. Oil on canvas,
38½ x 60 inches. Collection of G. Gordon Bellis.

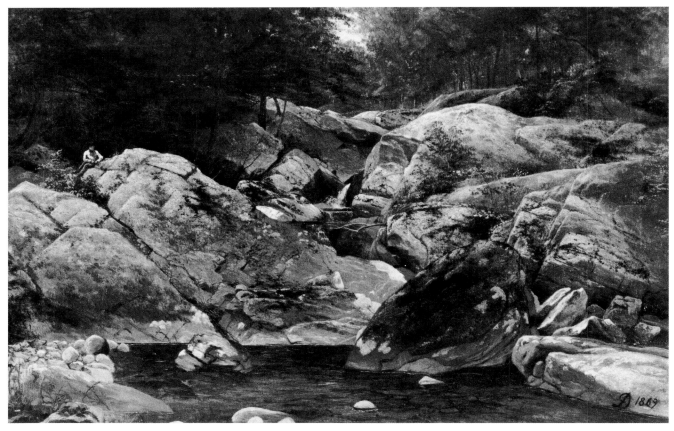

Cat. No. 23 *Highland Falls, West Point,* 1869. Oil on canvas, 16 x 24 inches.
Phoenix Art Museum, Gift of Dr. Ronald M. Lawrence, 65/177.

Centennial exhibition in Philadelphia in 1876, where he received some critical acclaim and a "first" award for his paintings. The three particular paintings chosen for the Centennial would all prove to be landmark works both in terms of the artist's professional standing and of his aesthetic development. *Brook Study at Warwick* was sold for $1000, which for Johnson's works at that time was a substantial sum; *Scenery on the Housatonic* (location unknown) was exhibited at the Paris Salon in 1877; and *Old Man of the Mountains* heralded a change in the artist's style.

Old Man of the Mountains is one of the artist's largest known paintings. Measuring approximately 60 by 48 inches, it was commissioned by Richard Taft, owner of the Profile House Hotel in New Hampshire, who probably hung the work in one of the public rooms at the mountain resort. The title of the painting derives from the rock profile of a man on the mountain in the center of the painting, a

celebrated natural wonder full of contemporary associations in literature and legend. At the lower left of the painting are tourists attracted to the spectacle of this human pattern found in nature; one man, seated on a bench in the foreground, points to the historic rock face.[61]

The inclusion of people in this painting, engaged in various tourist activities, would obviously be something that the purchaser, as the owner of a resort, would appreciate. In these years, Johnson would experiment more frequently with the inclusion of people in his paintings, now not simply in the background but often, as in *Old Man of the Mountains,* engaged in various activities — such as walking on a bridge or path — in the foreground. The new emphasis on people presented some challenges for the artist; in some paintings, the figures look as stiff and still as trees, while in others he is more successful at making them look human and alive. Although he

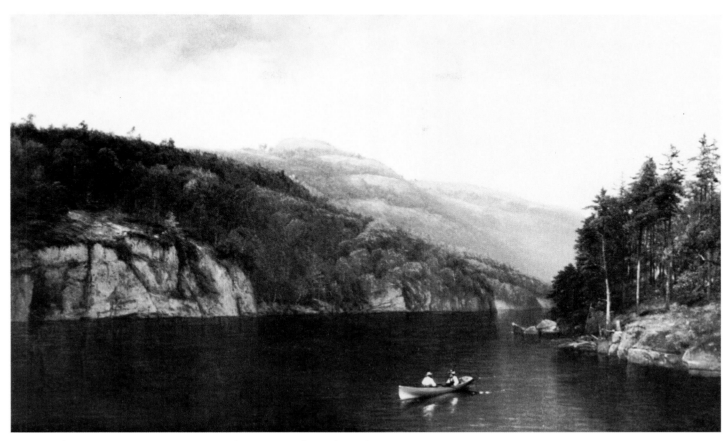

Cat. No. 26 *Boating on Lake George,* 1870. Oil on canvas, 16¼ x 26¼ inches.
On loan from NYNEX Corporation.

continued through the years to paint landscapes without people, the addition of this new type of genre composition to his repertoire shows that the artist was obviously developing in new directions.

Changes in style, changes in reputation

The fact that *Scenery on the Housatonic* was included in the 1877 exhibition of the Paris Salon was also an important achievement for the artist. Whether or not Johnson went to France around the time of the exhibition of his work in Paris, the evolution in his style indicates a new familiarity with a broad range of art. In the next twenty years, Johnson would draw upon the stylistic examples of many nineteenth century French artists, including Corot, Theodore Rousseau (1812-1867), Charles Daubigny (1817-1878), and Georges Michel (1763-1843), as well as Dutch seventeenth century landscape paintings by artists such as Jacob Ruysdael (1628/9-1682). Living in New York,

Johnson would have been able to see a variety of exhibitions of European art as well as prints of Old Master paintings. As early as the mid-1850's pictures by the French Barbizon painters were discussed in *The Crayon* and other periodicals[62]; by the late 1850s, Barbizon paintings were being exhibited in New York.[63] But the many and various developments in the artist's style were hardly limited to re-creations of a Barbizon style that was, by the 1870s, gaining in popularity among American collectors and artists.

Seascapes are rare in Johnson's known work, but two examples from the 1870s document his explorations in this very different direction. *Beacon Rock, Newport, Rhode Island* (private collection), from 1873, shows Johnson experimenting in the mode of the Newport paintings of John Kensett (who had died the previous year). *Sea Shore* (figure no. 5), a painting in which the only point of interest beyond the small ridged waves on the empty shoreline is a single

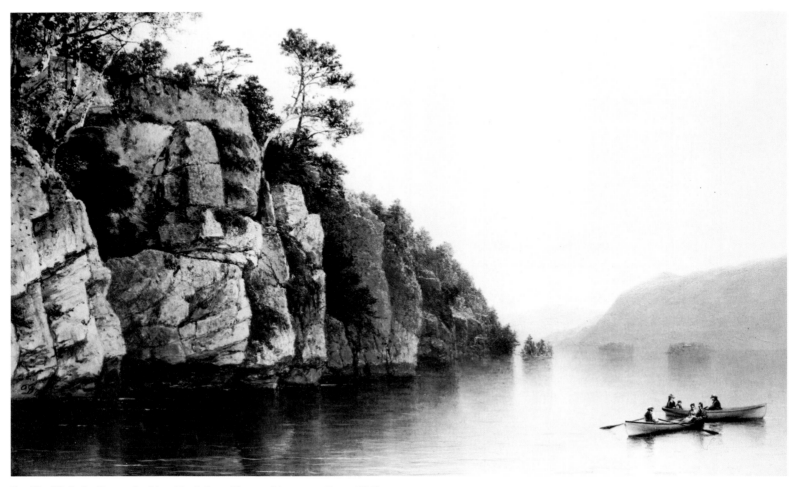

Cat. No. 32 *Lake George Looking North from Tongue Mountain Shore,* 1874.
Oil on canvas, 14⅛ x 22⅛ inches. The Adirondack Museum, Blue Mountain
Lake, NY

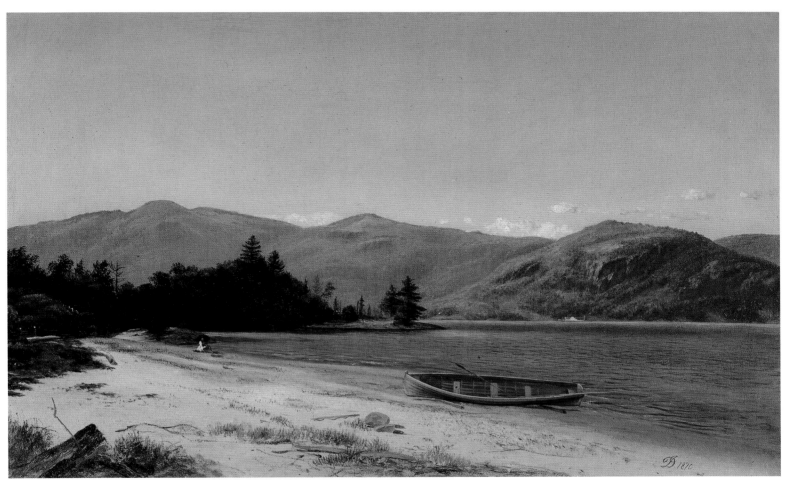

Cat. No. 27 *Study of Nature, Dresden, Lake George,* 1870. Oil on canvas,
13¾ x 21¾ inches. Albany Institute of History and Art, Gift of Mr. and Mrs.
Richard C. Rockwell

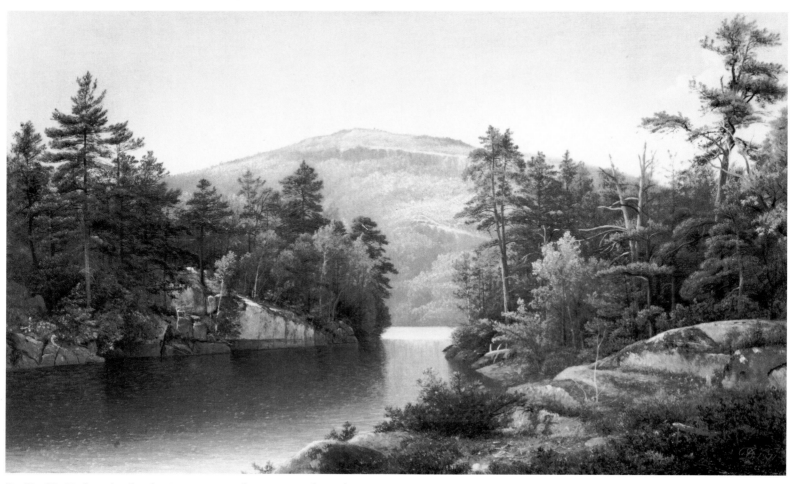

Cat. No. 28 *Harbor Island, Lake George,* 1871. Oil on canvas, 16⅜ x 26¼
inches. Collection of Henry Melville Fuller.

Cat. No. 46 *Lake George,* 1872. Pencil on paper, 12½ x 19 inches. The Janville Collection.

Cat. No. 45 *Mount Elephant, Lake George,* 1871. Pencil on paper, 12⁵/₁₆ x 19 inches. Bowdoin College Museum of Art, Brunswick, Maine.

small sailing ship on the horizon, recalls William Trost Richards' (1833-1905) marine paintings. Richards' exacting presentations of deep forest scenes in which each leaf appears to be drawn individually had won praise in *The New Path* in the 1860s.[64] He turned to marine painting with the same reverence for detail, but the subject, often a simple meeting of beach, ocean, and sky, made for a very different result; whereas Richards' forest scenes convey a sense of being closed in and overwhelmed by the abundance in nature, his seascapes draw attention to the expansive qualities of sea and shore. Johnson's painting does not have the level of specificity in the paint stroke that one finds in Richards' work, but the effect is the same: sea, sand, and sky as limitless space.[65]

By the end of the 1870s, Johnson concentrated more often upon river landscapes, now viewed from a close vantage point along the shoreline. But he approached this subject in various compositional styles. A comparison of *Study, Pompton, New Jersey* (cat. no. 35) of 1879 and *View of Pompton, New Jersey* (figure no. 6) of 1881 illustrates two ways that Johnson painted the same river within two years. The earlier painting is composed much like the paintings of Charles Daubigny; like the French artist's work, Johnson's pastoral scene has a low horizon line, with a vanishing point to the left or right of the center, delicate field flowers along the lower edge, and a mirror-like water surface reflecting a light-filled sky mottled with clouds. Johnson's 1881 view draws more upon the paintings of Jules Dupre (1811-1889), who often painted ponds and pools with cows before a background of large trees.

But in these later works the actual handling of the paint, rather than the composition or subject matter, is what distinguishes Johnson's paintings from those of his French models. Johnson continued to use a fine brush stroke, rather than a broader or varying stroke, and he continued to articulate the details of the natural forms. Thus, in his works trees never become generic landscape elements; they remain maples, oaks, beeches, chestnuts, and pines. Also, even though the colors he used in this era were darker, as was common in the tonal Barbizon paintings, Johnson continued to apply his paint thinly.

A great number of Johnson's later paintings, such as *On the Unadilla at New Berlin, New York* (cat. no. 36) and *Genesee River* (cat. no. 39), develop a compositional format that centers on a large tree, or several large trees. Both of these locations were the subjects of earlier Johnson paintings, but in these later works the site is painted with more dramatic contrasts of light and dark; the sky now generally is filled with a mass of billowing white clouds, while the trees block the light so that the foreground, with its scattering of cows or people or both, is in deep shadow. These compositions strongly recall the paintings of Theodore Rousseau, another in the group of French Barbizon painters. But again, the articulation of the finely painted details here, especially in the execution of the trees, distinguishes these paintings from their French models.

The painting of the substantial trees in these later compositions, with their meticulously rendered bark, leaves, and canopy, developed out of Johnson's life-long habit of making detailed drawings of the

47

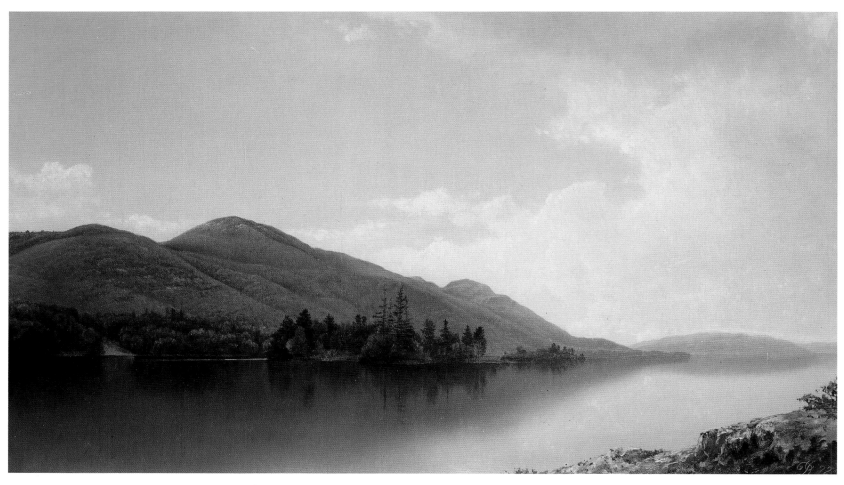

Cat. No. 29 *Buck Mountain, Lake George,* 1872. Oil on canvas, 15⅛ x 25 inches. Private collection, Courtesy, Berry-Hill Galleries, New York

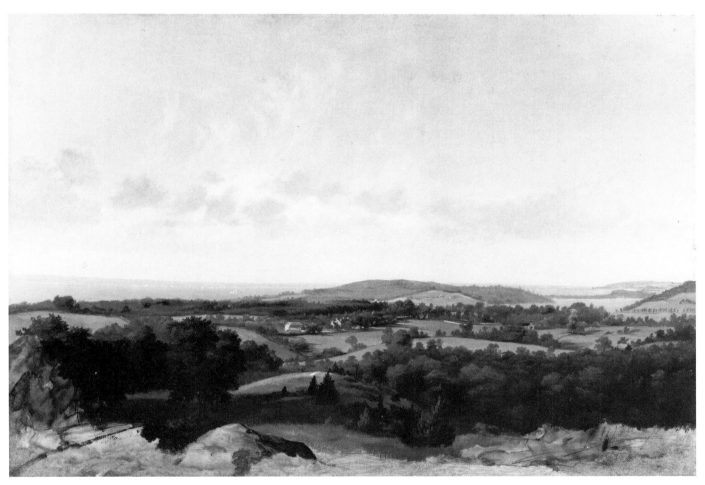

Cat. No. 30 *Near Warwick, New York,* c. 1873. Oil on canvas, 16½ x 24 inches.
Herbert F. Johnson Museum of Art, Cornell University, Membership Purchase
Fund 84.9

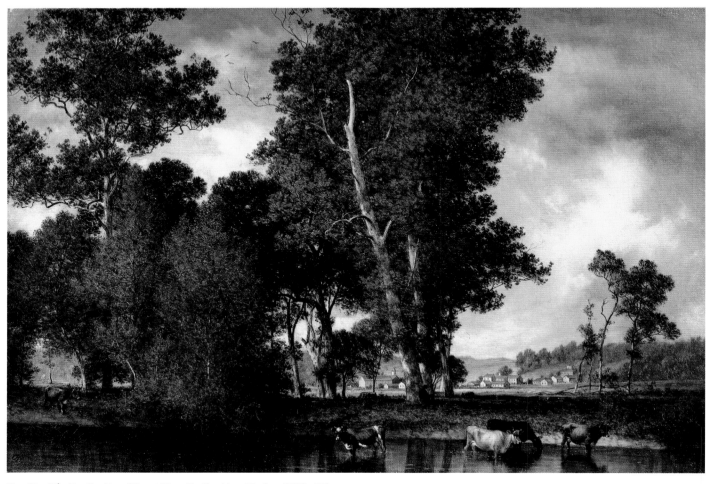

Cat. No. 36 *On the Unadilla at New Berlin, New York,* c. 1882. Oil on canvas,
18 x 26 inches. Alexander Gallery, New York

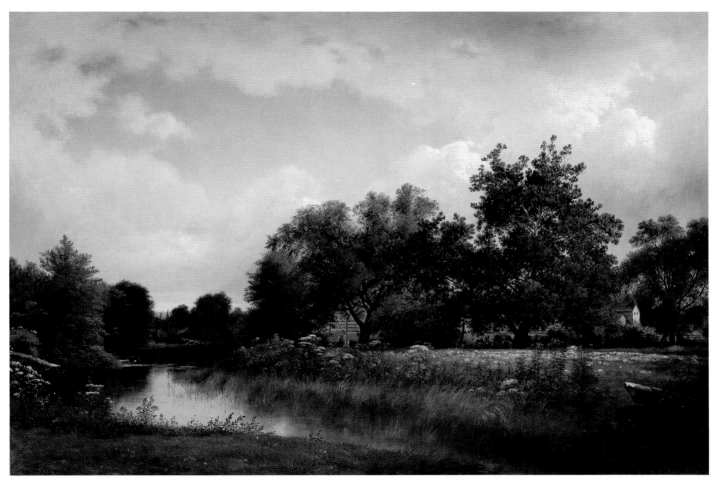

Cat. No. 35 *Study, Pompton, New Jersey,* 1879. Oil on canvas, 18¼ x 26¼
inches. Private collection.

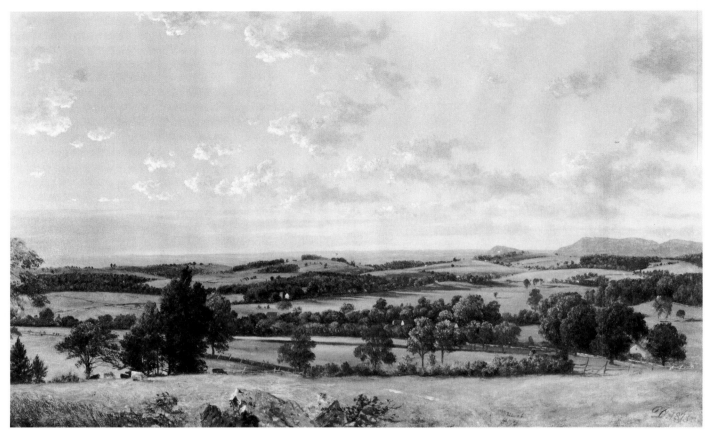

Cat. No. 31 *Study near Warwick, New York*, 1873. Oil on canvas, 13¼ x 21¼ inches. Private collection.

elements he used in his compositions. As preparatory studies for paintings in this format, Johnson made numerous drawings of specific species of trees. *Beach* (cat. no. 48) and *Chesnut* (cat. no. 49) are two examples of drawings which may or may not have been used as the basis for specific later paintings. In early drawings, Johnson had mainly sketched individual trees as they grew in relation to a group, but in these later drawings it is clear that each particular tree is truly the subject of the artist's investigations. Apparently now especially interested in the layered effects of leaves upon branches, Johnson often added white highlighting to accent the contrasts in his pencil studies.

The artist's interest in geography is less apparent in these later drawings and in the paintings that resulted. Whereas earlier drawings usually were inscribed with their location, later drawings tend only to be identified by tree type. Similarly, in the paintings Johnson created

using these drawings, with their focus on a tree rather than on a lake or a valley, the site loses its specificity — for example, the Unadilla River and the Genesee River look interchangeable. In *Passing Shower* (cat. no. 37) a painting in which the artist's compositional model was Dutch seventeenth century landscapes or the paintings of French artist Georges Michel which derive from Dutch models, the name of the locale is unnoted and unknown; the town in the background and the commonplace genre scene along the pathway appear to be universal rather than particular, and not even specifically American.

Surprisingly, some contemporary critics did not seem to notice that Johnson's later work had moved away from its firm grounding in the specifics of a locale. Writing in 1884, the nationalist critic of *The Art Age,* probably unfamiliar with Johnson's earlier work, commented on a new tree-centered landscape:

Mr. David Johnson utilized his summer worthily in painting the best landscape he has yet produced. It represents a clump of oaks in a pasture. In its wonderful fidelity to American landscape characteristics and its effect of artistic sincerity it is quite an exceptional work.[66]

But Johnson's changing style and his adoption of French Barbizon formats did not go unnoticed by everyone. Over the years, as Americans developed a taste for French painting and for art that was, in general, more tonal than linear and exacting, many American artists of Johnson's generation found themselves struggling to sell pictures. Fellow artist Jervis McEntee, though, noted enviously in his diary that this change in fashion had not left Johnson by the wayside. Reporting on a sale in New York in March 1885, he commented:

> Everything is done there to add distinction to the foreign pictures in comparison with American work, the latter being hung up high or in obscure places, except in the case of David Johnson, who has a picture almost exactly like Rousseau which is hung in a conspicuous place.[67]

McEntee later noted that Johnson was given favorable mention in *The World* newspaper because his paintings resembled those of Diaz and Rousseau.[68] For artists like McEntee, Cropsey, and others who found themselves struggling to survive without incorporating characteristics of Barbizon painting into their compositions, the praise of Johnson's work — which was, however, not universal[69] — certainly created resentment. Late in his life, Johnson earned the nickname the "American Rousseau," and in 1894, *The Studio* also hailed Johnson for his treatment of Barbizon subject matter, calling him "the best painter of trees in America."[70]

In reading contemporary criticism of Johnson's paintings, one finds that the artist had two distinct lives: one as a painter of the Hudson River School, and the second as a tonal painter of trees in the Barbizon style. But, it would be more correct to describe Johnson's interests as continually expanding: even as he experimented with new styles and subject matter, he also returned to earlier compositional styles rather than abandoning them altogether. *Phlox* (cat. no. 38), a still life dated 1886, is painted in the same style as the earlier *Apple Blossoms with May Flowers,* and a panoramic drawing of *Whaley Lake,* 1893 (collection of Dan Flavin),[71] seen from a hillside looking down, suggests that Johnson was planning a composition that would have been similar in style to his Lake George and Hudson River paintings of around 1870.[72] Often the late paintings explore the merger between two styles. *Bedford Station, Harlem Railroad* (location unknown),[73] a painting that does not show a railroad or a station, but whose title probably describes where the artist was seated when he sketched the scene, has been described by John I.H. Baur as "half Barbizon poetry, half luminous precisionism."[74]

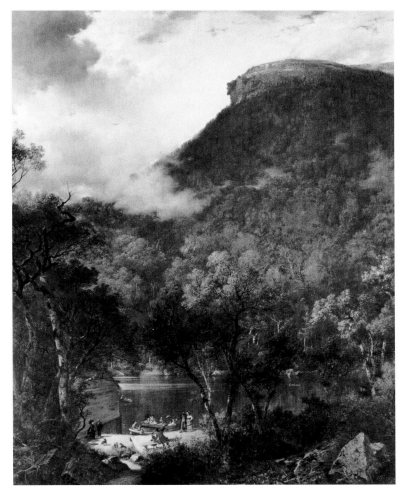

(Fig. 4) *Old Man of the Mountains,* 1876. Oil on canvas, 59¼ x 47⅛ inches, inscribed l.r.: DJ [monogram] 1876. Collection, State of New Hampshire.

Study near Trenton Falls, New York (cat. no. 40) of 1889 is another painting of a location which Johnson had painted at least two other times; there are dated paintings of Trenton Falls from 1866 and 1874. Both of these earlier paintings center on one of the six waterfalls on West Canada Creek, north and east of Utica, that had made Trenton Falls a popular tourist resort. But the falls are nowhere in evidence in the late painting, which pictures the creek at a tranquil point with large leafy trees on both sides. Mid-century tourists who had visited Trenton Falls would have found this later painting disappointing, because the waterfalls had been the main attraction for their long journey. (Trenton Falls was often visited on the way to the

(Fig. 5) *Sea Shore*, 1877. Oil on canvas, 11¾ x 20⅝ inches, inscribed l.r. DJ [monogram] 77. Robert Hull Fleming Museum, University of Vermont.

(Fig. 6) *View of Pompton, New Jersey,*1881. Oil on canvas, 45.7 x 66.4 cm, inscribed l.r.: DJ [monogram]. Gift of Lord Strathcona and his family, The Montreal Museum of Fine Arts, Collection, 937.304.

even more spectacular Niagara Falls.) Johnson's earlier Trenton Falls scenes were likely painted in the hope of selling them to this sort of tourist, or to would-be tourists who had read about the resort and its falls. By 1889, though, the resort was in decline. (By 1901, Trenton Falls had been dammed to generate electricity for the city of Utica.)[75] And clearly the aim of Johnson's painting had changed as well, presumably to accommodate the changing tastes of urban patrons whose travels were now more oriented to Europe, and who probably had never visited Trenton Falls. Rather than demanding a view of an exceptional landmark or of one specific upstate New York waterfall, this new audience was interested in a more generalized mode of landscape painting in which the setting could really represent many pastoral places. Johnson could have assumed that the potential purchaser of his later work would simply prefer a painting centering on an attractive grouping of trees by a placid river.

Near the end of the century, American expectations about landscape setting were clearly shifting. What had come to be considered important about the place shown in a painting is made even more apparent by the sale catalog of an auction of Johnson's paintings held in February, 1890. One-man sales, such as Johnson's, were usually held as a type of distress sale, when an artist found himself with a large stock of paintings and few buyers, and thus might be especially concerned that the catalog present his works in terms that the buyers would appreciate. In this catalog, Johnson's works are listed simply with their title and size. Now none of the descriptions

extols the natural beauty of Johnson's settings; indeed the only printed information that is added is for paintings of locations important in American history. *Old House at Hurley* (sale catalog no. 87), for example, is described as having been "occupied as a prison during the sacking of Kingston by the British."[76] It seems that at this point Johnson felt that he could best sell his paintings by their historical associations, even when they did not directly depict actual historic events.[77]

A telling example of these cultural changes in the late nineteenth century comes in the June 1900 edition of *The International Studio,* where the anonymous author of "American Studio Talk" uses the occasion of the death of Frederic Church to write a long, very characteristic, retrospective analysis of the history and current state of American landscape painting. This writer is extremely critical of Hudson River School painting, complaining that for all the emphasis on detail — Hudson River School painting and Pre-Raphaelite painting have here been combined into a single movement —

> when all was finished, the density of an oak was missing, the solidity of growing wood was not there, the tree trunk was no more able to withstand a north wind than would be a mammoth geranium plant. The best that can be said of this school is that it was perfectly sincere, and that there is a certain panoramic largeness in its compositions which gives them a degree of dignity that the present-day landscape, with its more modest and tamer motives, often lacks.

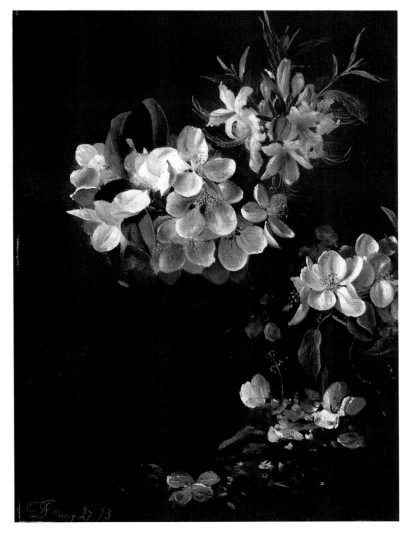

Cat. No. 34 *Sketch of Apple Blossoms with May Flowers,* 1873. Oil on board, 12½ x 9 inches. Private collection, Boston.

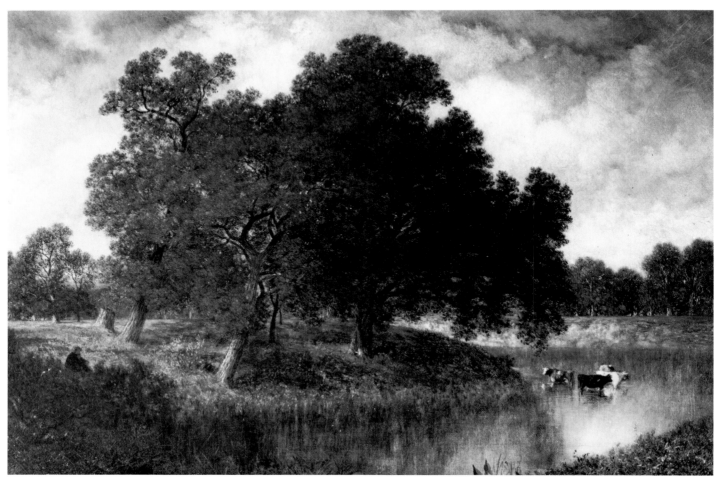

Cat. No. 39 *Genesee River,* 1888. Oil on canvas, 15⅝ x 22½ inches. Memorial Art Gallery of the University of Rochester; Marion Stratton Gould Fund.

Cat. No. 47 *Maple,* 1878. Pencil on paper with white highlighting, 11⅝ x 17¹³/₁₆ inches. Bowdoin College Museum of Art, Brunswick, Maine.

The author continues:

> The painter of this school whose productions were most artistic was, perhaps, David Johnson. His landscapes fully equal and closely resemble the early work of Rousseau. In the Metropolitan Museum we find his *Monarch of the Meadow*; it has quiet dignity and color that is not commonplace, nor are its distances wrongly expressed as the distances of Cole, who, like most artists of the Hudson River School, expressed the retreating of forms by means of the perspective diminution of objects and not by color values.[78]

Johnson here escaped criticism in *The International Studio* because the fashionable reviewer was most familiar with his later work, rather than with his earlier paintings. The work praised by the author of this article is actually a painting of 1888-89 now known only through its description in the 1931 catalog of the Metropolitan Museum as "a grove of large trees beneath which cattle are grazing; at the left a narrow stream winds through the landscape to the foreground."[79]

To survey fully the chronological progression of David Johnson's paintings is, in some ways, to survey a historical anthology of nineteenth century American landscape painting. A Hudson River School artist who incorporated elements of Barbizon and other popular European paintings styles into his work, Johnson was able to adapt and grow in directions different from those of his contemporaries. Because of these many stylistic shifts and experiments, few twentieth century critics have appreciated all of Johnson's paintings — indeed, few people have actually seen a representative sample of all of his work —and he has been repeatedly dismissed as an artist who seemed always to be searching for a style. Admirers of one particular period of his painting are often disappointed when they confront a work from a different decade, or sometimes even from the same decade but in a different mode. Finally, the transformations in Johnson's paintings provide a lesson that a landscape painting may be many things — there is no one right, accurate, or aesthetically valuable presentation, or any reason to say that a Hudson River School painting is more correct than a Barbizon-

Cat. No. 48 *Beach,* 1889. Pencil on paper with white highlighting,
12 x 16 inches. The Janville Collection.

influenced painting. David Johnson's strength as an artist is in his ability to utilize and combine aspects of many styles. The consistency in his work lies in his persistent fascination with nature's variety in color, shape, texture, and light. Throughout his career, Johnson worked to transcribe the diversity of these elements in his art.

NOTES

1. David Johnson, letter to G.W. Adams, 18 March 1878, Munson-Williams-Proctor Autograph Collection, Utica, New York.

2. *Lamb's Biographical Dictionary,* 1904 ed.

3. A letter from David Johnson to Mr. Nichols at the National Academy of Design, postmarked June 1, 1906, states that the portrait was painted by the artist's brother, Joseph Hoffman Johnson (David Johnson, Letter to Mr. Nichols, [1906], National Academy of Design Archives, New York.)

4. Clara Erskine Clement and Laurence Hutton, *Artists of the Nineteenth Century and Their Works: A Handbook* (1880; New York: Arno Press, 1969) p. 11; George C. Groce and David H. Wallace, *The New York Historical Society's Dictionary of Artists in America 1564-1860* (New Haven: Yale University Press, 1957), p. 353.

5. Along with the letter is a list of paintings, largely by European artists (Emil Charles Labinet, Timeloan Marie Lobrichon, Albert Arnz, Theodore (or Philippe) Rousseau and several others), which Walker wanted to sell to benefit Johnson's widow. (J.S. Walker, Letter to Charles C. Curran, 14 June 1924, National Academy of Design Archives, New York.)

6. The Janville family, in conversation, 15 February 1987. Johnson is listed as having an address in London in an 1862 catalog of an exhibiton at the Pennsylvania Academy of the Fine Arts. Margaret Conrads' careful research, however, has revealed that the handwritten card for the painting's entry actually lists no address; the London address may therefore be an erroneous assumption on the part of an organizer at the Academy. See Margaret Conrads in John I.H. Baur and Margaret C. Conrads, *Meditations on Nature: The Drawings of David Johnson* (Yonkers, New York: The Hudson River Museum, 1988) p.44.

7. School Register, National Academy of Design, New York. According to John Davis, a former research assistant at the NAD, the age given is consistent with the artist's 1827 birthdate.

8. "Art Items," *New York Daily Tribune,* 5 May 1861, p. 3, quoted in Baur and Conrads, p. 44.

9. John I.H. Baur, " '...the exact brushwork of Mr. David Johnson,' An American Landscape Painter, 1827-1908," *The American Art Journal* XII (Autumn 1980) pp. 48, 51 and note 10.

10. Baur, p. 52; Baur and Conrads, p. 44.

Cat. No. 49 *Chesnut,* 1891. Pencil on paper, 12 x 16½ inches. The Janville Collection.

11. Baur has shown that Johnson painted portraits based on photographs and other paintings. See Baur, p. 51, 52. The role that photographs played in the process of creating landscapes is unclear. See the discussion of *Mountain Landscape* later in this essay.

12. "Art Notes," *The New York Albion,* 26 June 1869, p. 365.

13. "Art Notes," *The New York Evening Post,* 17 June 1871, 1:2.

14. "Fine Arts," *The New York Evening Post,* 6 October 1876, 1:2.

15. The addresses are compiled in Baur and Conrads, p. 15-16.

16. John Davis, Letter to the author, 28 April 1986; see Eliot C. Clark, *History of the National Academy of Design* (New York: Columbia University Press, 1954) pp. 96-97.

17. Benjamin Champney, *Sixty Years' Memories of Arts and Artists* (Woburn, MA: Wallace & Andrews, 1900).

18. Diary of Jervis McEntee, roll D180, Archives of American Art, Smithsonian Institution, Washington, D.C.

19. The drawing which includes a sketch of Williamson is in the collection of Paul Worman Fine Arts, New York and the drawing in which Ordway is depicted is in the collection of Mrs. Edgar P. Richardson (reproduced in Baur and Conrads, p. 25).

20. John Davis, Letter to the author, 28 April 1986. Davis notes that "very few artists actually made entries into the [library] register, indicating that Johnson was either unusually conscientious or that he was one of the few painters to take books home from the Library rooms."

21. David Johnson, Letter to G.W. Adams, 18 March 1878, Munson-Williams-Proctor Autograph Collection, Utica, New York.

22. Speculation that some paintings were later signed on the verso arises from the observation that many of the paintings have inscriptions (location, date, artist's name) written in a hand that is so similar as to suggest that they were all signed at the same time.

23. Mary Bartlett Cowdrey, *National Academy of Design Exhibition Record, 1826-1860* (New York: Printed for the New York Historical Society, 1943) p. 270; Mary Bartlett Cowdrey, *American Academy of Fine Arts and American Art Union Exhibition Record 1816-1852* (New York: The New York Historical Society, 1953) p. 209.

24. William S. Talbot, *Jasper F. Cropsey 1823-1900,* diss. New York University, 1972 (New York: Garland Publishing, Inc., 1977) p. 71.

25. The painting is described in the records of the American Art-Union as follows: "The river is in the foreground, with a man fishing from the rocks. In the middle distance is a ledge of rocks, over which the water falls. Near by are the ruins of a mill." (Cowdrey, *American Academy,* p. 209.)

26. Asher B. Durand mentioned in a letter of 28 September 1849 seeing Kensett and Casilear along with a German artist, W. Volmering, in Tannersville, a town not far from Haines Falls, but there is no mention of David Johnson. Asher B. Durand Papers, New York Public Library.

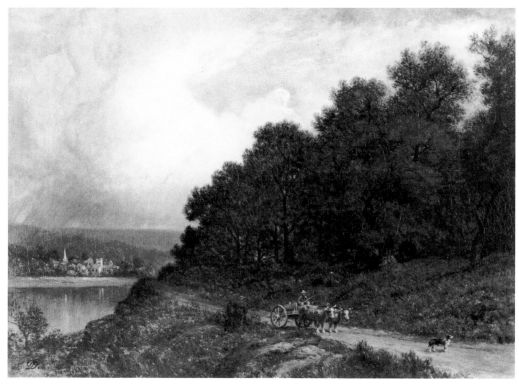

Cat. No. 37 *Passing Shower,* c. 1885. Oil on canvas, 13 x 17 inches. Mead Art Museum, Amherst College, Gift to the Herbert W. Plimpton Collection from Gabriella Plimpton Ressler and Dr. Herbert W. Plimpton, Jr.

27. There are two towns in New York state called Elizabethtown, one in the central part of the state not far from New Berlin, and one in the Adirondacks in Essex County. The waterfall in this drawing could have been in either location.

28. For a discussion of the Pre-Raphaelite movement in America see Roger Stein, *John Ruskin and Aesthetic Thought in America, 1840-1900* (Cambridge, MA: Harvard University Press, 1967) and Linda Ferber and William Gerdts, *The New Path: Ruskin and the American Pre-Raphaelites* (New York: The Brooklyn Museum and Schocken Books, 1985).

29. John Henry Hill (1839-1922), a member of the group, recorded a visit from David Johnson and his wife in his diary on June 12, 1871. (May Brawley Hill, "John Henry Hill," in Ferber and Gerdts, p. 179).

30. Worthington Whittredge, "The Autobiography of Worthington Whittridge, 1820-1910," edited by John I.H. Baur, *Brooklyn Museum Journal,* 1942, p. 55, quoted in Ferber, "Determined Realists," in Ferber and Gerdts, p. 15.

31. Numerous paintings by Johnson were titled "Study of...". The "study" was a type of composition advocated by *The New Path* as the appropriate first step for a young artist, that of copying nature. See Ferber, p. 25, in Ferber and Gerdts, for a discussion of "Naturalism and Genius" by J.S. in *The New Path* 1, (no. 6) (October 1863), pp. 64-70. It is interesting to note that although many other painters exhibited works in NAD exhibitions in the 1850s that were called "Study," Johnson did not show works with this title at the NAD until 1865, indicating that perhaps he read and was influenced by this article.

32. Franklin Kelly, " 'Elevating the Commonplace:' Frederic Church and the National Landscape," Metropolitan Museum of Art, New York, 12 December 1987.

33. Baur, p. 44. *Study of a Pine, West Milford* is illustrated in this article on page 36.

34. Many other artists did paint views along the Mohawk River which showed the canal. See Patricia Anderson, *The Course of Empire: The Erie Canal and the New York Landscape 1825-1875* (Rochester: Memorial Art Gallery of the University of Rochester, 1984).

35. The varieties of pears in the painting are likely (from left to right) a Bartlett, an Elizabeth, and a Seckel. See U.P. Hedrick, *The Pears of New York* (Albany, NY: J.B. Lyon Company, 1921) for the history of pears in New York and excellent plates showing the varieties grown.

Johnson may have been seriously interested in the development of American agriculture; fruit cultivation was an important subject in scientific journals of the era. (William Gerdts, "The Bountiful Harvest: Still Life Paintings by Artists of the Hudson River School," Metropolitan Museum of Art, New York, 12 December 1987.)

36. I am grateful to Ian Merwin at Cornell University for his help in identifying the apples. Merwin noted that the fruit is "surprisingly realistic — even the blemishes

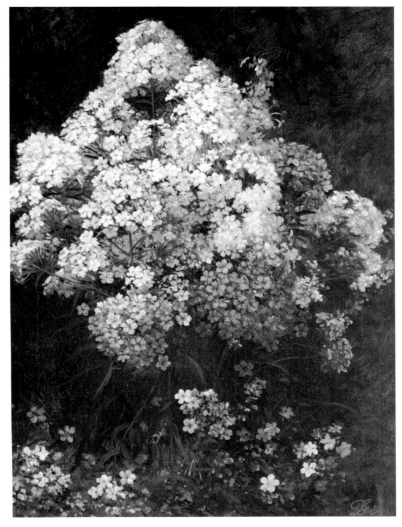

Cat. No. 38 *Phlox,* 1886. Oil on canvas, 19½ x 14½ inches. Reynolda House, Museum of American Art.

and lesions of apple scab disease which are diagnostically precise." Ian Merwin, Letter to the author, 5 July 1988.

Johnson is not known to have exhibited any of his still lifes; the inscription on *Three Pears and an Apple,* "Compliments of D. Johnson," implies that the work was perhaps a gift to a friend.

37. Miniatures are rare in Johnson's oeuvre. The only other one known to the author is of Natural Bridge (private collection).

38. A drawing of Natural Bridge (private collection), illustrated in Baur, p. 45, and Baur and Conrads, p. 40, is signed and dated 1860. See Pamela H. Simpson, *So Beautiful an Arch: Images of the Natural Bridge 1787-1890* (Lexington, Va.: Washington and Lee University, 1982) for a history of paintings of the Natural Bridge.

39. Carrie Rebora, "Jasper Cropsey," p. 210 in John Howat et al., *American Paradise: The World of the Hudson River School* (New York: Metropolitan Museum of Art, 1987); see also Roger B. Stein, *Susquehanna: Images of the Settled Landscape* (Binghamton, NY: Roberson Center for the Arts and Sciences, 1981) pp. 62-63.

40. Rebora, p. 211 in Howat, *American Paradise.*

41. White birch trees often grow when a forest has been disturbed by fire, logging, or storm damage.

42. The drawing is illustrated in Baur and Conrads, p. 46.

43. Baur, p. 52.

44. I am grateful to David Findlay for drawing my attention to the painting and providing photographs of Twin Lakes for comparison.

45. Illustrated in Baur, p. 39, and Baur and Conrads, p. 27.

46. I am grateful to Eric Craddock at the Colorado Historical Society for information about photographs of Twin Lakes.

47. The bibliography on Cole's painting is extensive. See Oswaldo Rodriguez Rogue, "Thomas Cole," in Howat, *American Paradise,* p. 125-129 and notes for further references.

48. Ferber, in Ferber and Gerdts, p. 37.

49. Johnson did not necessarily inscribe the title and date on his canvases at the time that they were painted, and his after-the-fact inscriptions sometimes mistake one location for another. For example, a painting titled *Morning at the Harbor Islands, Lake George* 1879, (private collection) actually represents a scene on the Hudson River.

50. The area around West Campton has been for many years the subject of a continuing series of studies of forest history and development conducted by researchers from Yale University and Cornell University. According to F.H. Bormann, who has been associated for many years with these studies, this painting may indeed depict the valley as it would have appeared in the mid-nineteenth century. (F.H. Bormann, Letter to the author, 26 June 1988.)

51. A second version of the same subject, *A Study of a Birch, Lancaster, New Hampshire* (location unknown), shows the same tree from a different angle, but also depicts it in the foreground before a view of the valley.

52. Although these tree paintings are unusual among the works by Johnson which are known today, many titles noted in nineteenth century sources, such as *White Birch, Adirondacks* and *Maples at Geneseo,* suggest that the artist painted other compositions in which the trees were the central focus. Without dates for these unknown paintings, one does not know whether they should be categorized stylistically with *Young Elms* (cat. no. 13), these birch and cedar paintings, or the artist's later period.

53. Frederic F. van de Water, *Lake Champlain and Lake George,* The American Lake Series, ed. by Milo M. Quaife (New York: Bobbs-Merrill Co., 1946) p. 328.

54. See Betty Ahearn Buckell, *Old Lake George Hotels: A Pictorial Review* (Lake George: Buckle Press, 1986) for information about the hotels on the lake.

55. An extremely unusual painting of a fire, *Fire on Black Mountain* (private collection), pictures a boating party on the lake watching the fire, which is presented more as a curiosity than as a natural disaster.

56. Johnson painted a substantially larger view of this same location in 1876, now titled *View on Lake George (Paradise Bay)* (collection of Manufacturers Hanover). Although some trees have been altered for dramatic effect, others are drawn to look very similar to those in the earlier painting, only slightly larger, suggesting that the artist went back and made new sketches showing the new growth of the trees.

57. Carrie Rebora, *Jasper Cropsey Watercolors* (New York: National Academy of Design, 1985) p. 92.

58. Apples are grown today near Warwick, New York and it would be easy to associate these flowers with Johnson's stay in the area were it not for the fact that in the mid-19th century apples were grown much more widely and, indeed, were a product in the majority of counties in New York State.

59. An oil sketch by Cropsey from the same year, *Wooded Landscape* (1873, Newington-Cropsey Foundation), depicts a similar rocky stream that may, if one takes into account the variations in the two artists' approaches to the subject, even be the same place.

60. David Johnson, Letter to G.W. Adams.

61. The man in the painting is identified in a preparatory drawing (now in the collection of Graham Gallery) as "Mr. John Kellock/model." See Baur and Conrads, p. 72.

62. Peter Bermingham, *American Art in the Barbizon Mood* (Washington, D.C.: Published for the National Collection of Fine Arts by the Smithsonian Institution Press, 1975) p. 43.

63. The National Academy of Design, for example, held an exhibition of contemporary European painting in 1859. See Samuel Putnam Avery, *The Diaries 1871-1882 of Samuel P. Avery, Art Dealer,* eds., Madeleine Fidell Beaufort, Herbert L. Kleinfield and Jeanne K. Welcher, (New York: Arno Press, 1979) p. xviii. Samuel Avery, a picture dealer instrumental in bringing this collection to the NAD, owned at least one painting by Johnson, *View in Essex County,* which was exhibited at the National Academy of Design in 1859. (Cowdrey, *National Academy,* p. 270).

64. Linda Ferber, *William Trost Richards: American Landscape and Marine Painter* (Brooklyn, NY: The Brooklyn Museum, 1973) p. 26.

65. Although Johnson's *Sea Shore* was sold soon after it was exhibited at the National Academy of Design in 1877, the subject was not one in which the artist seemed to have a continuing interest. Records at the Robert Hull Fleming Museum at the University of Vermont show that *Sea Shore* was in the University's Park Gallery collection by 1877-78. The artist did not record the title of the work on the back of this canvas; the only notations in the artist's hand, written on the frame, record the size and his name.

66. "Studio Notes," *Art Age,* (1884) p. 2.

67. Diary of Jervis McEntee, 19 March 1885.

68. Diary of Jervis McEntee, 14 October 1886.

69. See, for example, the comments of Edward Strahan in his review of the National Academy of Design's 1879 exhibition. Strahan found Johnson's *Landscape with Sheep* to have "effects a la Dupre and Jacque." (Edward Strahan, "The Art Gallery: The National Academy of Design. First Notice," *Art Amateur* I (June 1879) p. 4, quoted in Doreen Bolger Burke and Catherine Hoover Voorsanger, "The Hudson River School in Eclipse," in Howat et al., *American Paradise,* p. 72.)

70. "What our artists are doing," *The Studio* (New York) IX (28 April 1894) p. 1.

71. Illustrated in Baur and Conrads, p. 86.

72. Baur and Conrads, p. 86.

73. Illustrated in Baur, p. 65.

74. Baur, p. 65.

75. Howard Thomas, *Trenton Falls: Yesterday and Today* (Prospect, NY: Prospect Books, 1951) p. 144.

76. Ortgies & Co., *Catalogue of Paintings in Oil by David Johnson, N.A.,* Fifth Avenue Art Galleries, February 13-14, 1890, p. 87.

77. The priced copy of the Ortgies sale catalog in the collection of the American Antiquarian Society has prices listed for only a very small number of paintings, suggesting perhaps that there were no buyers for many of the pictures. Without other evidence, though, it is risky to conclude that the sale was a failure; the person who owned this catalog may simply not have bothered to write in many prices.

78. "American Studio Talk," *The International Studio* X (June 1900) Supplement, p. iii. *The Monarch of the Meadow* (also called *The Giant of the Meadow*) is no longer in the collection of the Metropolitan Museum in New York.

79. Bryson Burroughs, *The Metropolitan Museum of Art Catalogue of Paintings,* ninth ed. (New York: Metropolitan Museum of Art, 1931) p. 190.

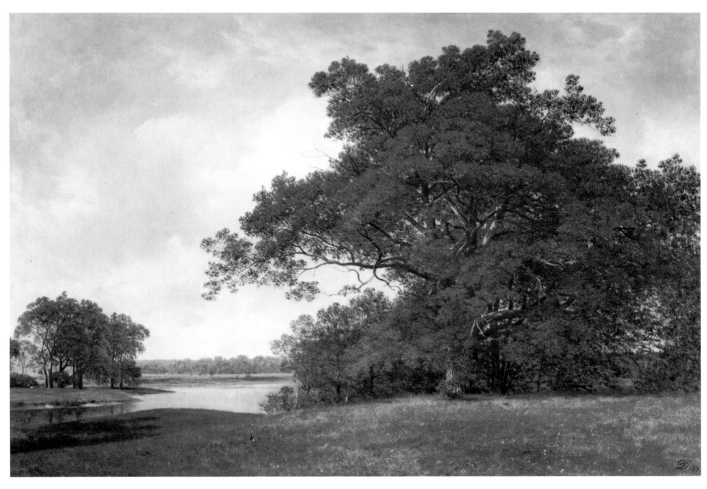

Cat. No. 40 *Study near Trenton Falls, New York,* 1889. Oil on canvas, 18½ x
26½ inches. Kenneth Lux Gallery, New York.

CATALOG OF THE EXHIBITION

PAINTINGS

1 *Haines Falls, Kauterskill Clove,* 1849
oil on canvas, 16 x 14½ inches
inscribed l.r.: D.J. 1849
 on verso: Haines Falls./Kauterskill Clove./David
 Johnson./1849./My first Study from Nature/made in company
 with J.F. Kensett. &/J.W. Casilear.
Collection of Marilyn Kerner

2 *Fannie Glen, New Jersey,* 1850
oil on canvas, 17 x 22¾ inches
inscribed l.c.: D. Johnson 1850
Anonymous loan

3 *Old Mill, West Milford, New Jersey,* 1850
oil on canvas, 17 x 13 inches
inscribed l.r.: D. Johnson Sept. 1850
 on verso: Old Mill. West Milford, N-J/D. Johnson. 1850.
The Brooklyn Museum, Gift of Peter A. Leman 08.223

4 *Forest Rocks,* 1851*
oil on canvas, 17 x 21 inches
inscribed l.l.: D.J. 1851 and l.r.: D. Johnson/1851
 on verso: Study, North Conway, N.H. David Johnson 1851
The Cleveland Museum of Art, Mr. and Mrs. William H. Marlatt Fund
CMA 67.125

5 *A Study, Bash Bish Falls,* 1856
oil on canvas, 15 x 20 inches
inscribed 1.1.: D.J. 56
 on verso: A Study, Bash-Bish Falls/D. Johnson 1856
Collection of Mr. and Mrs. David A. McCabe

6 *Three Pears and an Apple,* 1857**
oil on academy board, 11⅜ x 16⅛ inches
inscribed l.r.: with Compliments of D. Johnson 1857.
Anonymous loan

7 *Apples and Quinces,* c. 1857
oil on canvas, 10¼ x 12½ inches
inscribed l.r.: D.J.
Spanierman Gallery, New York

8 *Harlem River Aqueduct,* 1860
oil on canvas, 7¾ x 13 inches
inscribed l.r.: D.J. 1860
Hirschl & Adler Galleries, Inc., New York

9 *High Bridge,* c. 1860
oil on paper, 5 x 4 inches
inscribed l.l.: DJ (monogram)
Collection of Jeffrey and Dana Cooley

10 *Natural Bridge, Virginia,* 1860
oil on canvas, 14½ x 22¼ inches
inscribed l.r.: D.J. 1860
Reynolda House, Museum of American Art

11 *A Study near Tamworth, New Hampshire,* 1863
oil on canvas, 16½ x 13¾ inches
inscribed l.l.: DJ (monogram)
 on verso: A Study at Tamworth, N-H/David Johnson/1863
D. Wigmore Fine Art, Inc., New York

12 *Study at Tamworth, New Hampshire,* 1863
oil on canvas, 13⅝ x 16¾ inches
inscribed l.l.: DJ (monogram)
 on verso: Study at Tamworth. N.H./David Johnson 1863
Kenneth Lux Gallery, New York

13 *Young Elms,* 1863
oil on canvas, 17½ x 14½ inches
inscribed l.r.: D. Johnson 63
Private collection

14 *Eagle Cliff, Franconia Notch, New Hampshire,* 1864
oil on canvas, 27¼ x 44¼ inches
inscribed l.l.: DJ (monogram)
 on verso: Eagle Cliff, Franconia Notch. N-H/David Johnson. 1864.
Amon Carter Museum, Fort Worth

15 *Scene at Bethel, Maine,* 1866**
oil on canvas, 14 x 22 inches
inscribed l.r.: DJ (monogram) 66
 on verso: Scene at Bethel, Maine/David Johnson, 1866
Private collection

16 *Echo Lake, New Hampshire,* 1867
oil on canvas, 30 x 40 inches
inscribed l.r.: DJ (monogram) 1867
Private collection, New Jersey

17 *A Study near Lancaster, New Hampshire,* 1867
oil on canvas, 13 x 22 inches
inscribed l.r.: DJ (monogram) 67
 on verso: A Study Near Lancaster N-H/David Johnson 1867.
Collection of Mr. and Mrs. David A. McCabe

18 *Study of a Cedar,* c. 1867
oil on canvas, 20 x 14 inches
inscribed l.r.: DJ (monogram)
Montgomery Gallery

19 *Study, Franconia Mountains from West Campton, New Hampshire,* c. 1867
oil on canvas, 14½ x 26 inches
inscribed l.r.: DJ (monogram)
 on verso: Study, Franconia Mountains from West Campton. N-H.
 D. Johnson
Wadsworth Atheneum, Hartford. Bequest of
Mrs. Clara Hinton Gould.

20 *The Connecticut River at North Littleton, New Hampshire,* 1867
oil on canvas, 14 x 22 inches
inscribed l.r.: DJ (monogram)
Private collection

21 *Androscoggin River,* 1869
oil on canvas, 14 x 22 inches
inscribed l.r.: DJ (monogram) 69
 on verso: Study. Androscoggin River. David Johnson. 1869
Private collection. Courtesy, Berry-Hill Galleries, New York

22 *View from New Windsor, Hudson River,* 1869
oil on canvas, 38 x 60½ inches
inscribed l.r.: DJ (monogram) 1869
Collection of Elizabeth and Robert Sincerbeaux

23 *Highland Falls, West Point,* 1869
oil on canvas, 16 x 24 inches
inscribed l.r.: DJ (monogram) 1869
Phoenix Art Museum, Gift of Dr. Ronald M. Lawrence, 65/177

24 *Hudson River from Fort Montgomery,* 1870
oil on canvas, 38½ x 60 inches
inscribed l.r.: DJ (monogram) 1870
 on verso: Hudson River. from Fort Montgomery./David Johnson.
Collection of G. Gordon Bellis

25 *A Hudson River Reminiscence,* 1870
oil on canvas, 14 x 22 inches
inscribed l.r.: DJ (monogram) 1870
 on verso: A Hudson River Reminiscence/David Johnson 1869.70
 on stretcher: Constitution Island
Collection of Benjamin C. Buerk

26 *Boating on Lake George,* 1870**
oil on canvas, 16¼ x 26¼ inches
inscribed l.r.: DJ (monogram) 1870
On loan from NYNEX Corporation

27 *Study of Nature, Dresden, Lake George,* 1870
oil on canvas, 13¾ x 21¾ inches
inscribed l.r.: DJ (monogram) 1870
 on verso: Study of Nature-Dresden-Lake George. David Johnson
 1870
Albany Institute of History and Art, Gift of
Mr. and Mrs. Richard C. Rockwell

28 *Harbor Island, Lake George,* 1871
oil on canvas, 16⅜ x 26¼ inches
inscribed l.r.: DJ (monogram) 1871
 on verso: Harbor Island/Lake George/David Johnson 1871
Collection of Henry Melville Fuller

29 *Buck Mountain, Lake George,* 1872
oil on canvas, 15⅛ x 25 inches
inscribed l.r.: DJ (monogram) 1872
Private collection. Courtesy, Berry-Hill Galleries, New York

30 *Near Warwick, New York,* c. 1873
oil on canvas, 16½ x 24 inches
unsigned
Herbert F. Johnson Museum of Art, Cornell University,
Membership Purchase Fund 84.9

31 *Study near Warwick, New York,* 1873
oil on canvas, 13¼ x 21¼ inches
inscribed l.r.: DJ (monogram) 1873
 on verso: Study near Warwick/David Johnson
Private collection

32 *Lake George Looking North from Tongue Mountain Shore,*
1874
oil on canvas, 14⅛ x 22⅛ inches
inscribed l.l.: DJ (monogram) 74
 on verso: Lake George/David Johnson. 1874.
 on stretcher: Looking north from Tongue Mountain shore
The Adirondack Museum, Blue Mountain Lake, NY

33 *Brook Study at Warwick,* 1873
oil on canvas, 26 x 40 inches
inscribed l.r.: DJ (monogram) 1873
 on verso: Brook Study at Warwick, N-Y DJ (monogram) 1873
Munson-Williams-Proctor Institute, Utica, NY

34 *Sketch of Apple Blossoms with May Flowers,* 1873
oil on board, 12½ x 9 inches
inscribed l.l.: DJ (monogram) May 27 '73
 on verso: Sketch of/Apple Blossoms./with May Flowers./David
 Johnson May 27th/1873.
Private collection, Boston

35 *Study, Pompton, New Jersey,* 1879
oil on canvas, 18¼ x 26¼ inches
inscribed l.l.: DJ (monogram) 79
Private collection

36 *On the Unadilla at New Berlin, New York,* c. 1882
oil on canvas, 18 x 26 inches
inscribed l.l.: DJ (monogram)
 on verso: On the Unadilla/at New Berlin, N-Y/David Johnson
Alexander Gallery, New York

37 *Passing Shower,* c. 1885
oil on canvas, 13 x 17 inches
inscribed l.l.: DJ (monogram)
Mead Art Musem, Amherst College, Gift to the Herbert W. Plimpton
Collection from Gabriella Plimpton Ressler and Dr. Herbert W.
Plimpton, Jr.

38 *Phlox,* 1886
oil on canvas, 19½ x 14½ inches
inscribed l.r.: DJ (monogram) 86
Reynolda House, Museum of American Art

39 *Genesee River,* 1888
oil on canvas, 15⅝ x 22½ inches
inscribed l.l.: DJ (monogram)
 on verso: Genesee River/David Johnson 1888
Memorial Art Gallery of the University of Rochester; Marion Stratton
Gould Fund

40 *Study near Trenton Falls, New York,* 1889
oil on canvas, 18½ x 26½ inches
inscribed l.r.: DJ (monogram)
 on verso: Study near Trenton Falls, N.Y./David Johnson/1889
Kenneth Lux Gallery, New York

WORKS ON PAPER

41 *Elizabeth Town,* 1859
pencil on paper, 15¼ x 10 inches
inscribed in pencil at l.r.: D.J. Elizabeth Town July 59
The Janville Collection

42 *Harlem River Aqueduct,* c. 1860
pencil on paper, 12¼ x 18⅛ inches
unsigned
Paul Worman Fine Art, New York

43 *White Mountains from Lancaster, New Hampshire,* 1867
pencil on paper, 12¾ x 18 inches
inscribed in pencil at l.l.: White Mountains/from Lancaster
N.H./DJ (monogram). September 2′ 1867
along lower edge of sheet: Mt Madison.—Mt Adams.—
Mt Jefferson.—Mt Washington.—Mt Monroe—
Mt Clinton—Mt Pleasant.—
Paul Worman Fine Art, New York

44 *Mouth of the Moodna on the Hudson,* 1869
1870 steel engraving on paper by G.W. Wellstood after an 1869
painting by David Johnson, 5¹/₁₆ x 8 inches (plate)
engraved in plate: DJ (monogram) 1869
Private collection

45 *Mount Elephant, Lake George,* 1871
pencil on paper, 12⁵/₁₆ x 19 inches
inscribed in pencil at l.r.: Mount Elephant-/Lake George-/
DJ (monogram).1871/Harbor Islands
Bowdoin College Museum of Art, Brunswick, Maine

46 *Lake George,* 1872
pencil on paper, 12½ x 19 inches
inscribed in pencil at l.l.: Lake George./DJ (monogram). 1872
The Janville Collection

47 *Maple,* 1878
pencil on paper with white highlighting, 11⁵/₈ x 17¹³/₁₆ inches
inscribed in pencil at l.r.: DJ (monogram).78./-Maple-
Bowdoin College Museum of Art, Brunswick, Maine

48 *Beach,* 1889
pencil on paper with white highlighting, 12 x 16 inches
inscribed in pencil at l.l.: Beach/DJ (monogram)/ No. 61.
The Janville Collection

49 *Chesnut,* 1891
pencil on paper, 12 x 16½ inches
inscribed in pencil at l.r.: Chesnut. DJ (monogram) 1891./No 69
The Janville Collection

 * indicates work shown only at the Herbert F. Johnson
 Museum of Art
** indicates work shown only at the Herbert F. Johnson
 Museum of Art and the National Academy of Design

A WORKING LIST OF PAINTINGS BY DAVID JOHNSON

This list is not a systematic catalog of David Johnson's oil paintings but simply a working list compiled by the author for research purposes and published here to give the reader a general sense of the artist's oeuvre. Not all paintings listed have been located or seen by the author and there are certainly more that remain undiscovered. Paintings are listed alphabetically, rather than by year, since many works are undated. The format for the list is as follows:

> Title
> date (if known)
> size in inches (if known)
> reference

Only one reference for an owner or a source for further information is given for each painting. The following abbreviations and short titles are used:

Art Market
> Works offered for sale, with current owner not identified.

Baur, p.
> Baur, John I.H. "'…the exact brushwork of Mr. David Johnson,' An American Landscape Painter, 1827-1908." *The American Art Journal* XII (Autumn 1980), pp. 32-55

Christies
> Christies, Manson and Woods, Inc. auction sale with number, date of sale, and lot number

IAP
> Inventory of American Paintings, Smithsonian Institution

NAD
> National Academy of Design, New York, exhibition record

ORT #
> Ortgies & Co. *Catalogue of Paintings in Oil by David Johnson, N.A.* to be sold by auction February 13th-14th at Fifth Avenue Art Galleries…by Ortgies & Co., New York, 1890

SPB
> Parke Bernet or Sotheby Park Bernet, Inc. auction sale with number, date of sale, and lot number

References to commercial art galleries are listed by name of the gallery, and unless the city is listed after the name, the reader can assume that the firm is located in New York City.

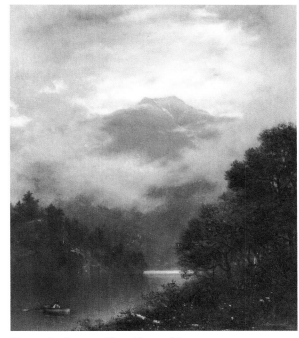

Mount Lafayette, New Hampshire
date unknown
17 x 14
Collection of Howard Godel, Bedford Hills, NY

Adirondack Lake
1883
5 x 9
Reproduced *Kennedy Quarterly,*
vol. 7 (1967), p. 206

Adirondack Scenery
1864
12 x 20½
Parrish Art Museum

Adirondacks
date unknown
size unknown
IAP

Afternoon Pastures
date unknown
11½ x 15½
Pioneer Museum and Haggin Galleries

Along the Mohawk
1855
30 x 24
Private collection

Along the Wooded Path
1874
10 x 12
IAP

Alpine Lake
unknown date
4¾ x 9
Reproduced *Kennedy Quarterly,*
vol. 16 (1978), p. 173

An Approaching Storm
unknown date
7¼ x 10¾
SPB sale no. 4316 (9/27/79) #891

Androscoggin River
1869
14 x 22
Private collection

Apples and Quinces
c. 1857
10¼ x 12½
Spanierman Gallery, New York

At Barrytown, Hudson River
date unknown
15½ x 25½
ORT #23

At Bash Bish Falls, New York
date unknown
15½ x 10½
ORT #28 or #44

At Dashville, Ulster Co. N.Y.
date unknown
9½ x 15½
ORT #97

At Joyceville, Connecticut
date unknown
17½ x 25½
ORT #110

At Linwood, Greenwich, Conn.
date unknown
20½ x 12½
ORT #6

At Ramapo, New York
date unknown
21½ x 17½
ORT #25

At Tamworth, New Hampshire
date unknown
13½ x 21½
ORT #19

Autumn Sketch
c. 1851
size unknown
NAD 1852 no. 467

Autumn on the Ramapo
date unknown
13 x 21
ORT #47

Autumn, Ramapo
date unknown
9½ x 16
ORT #13

Bash Bish Falls at Copake
date unknown
19½ x 15½
ORT #88

Bayside, New Rochelle
1888
19½ x 24
Metropolitan Museum of Art

*Bear Fort Mountains, West Milford,
New Jersey*
date unknown
11 x 22½
ORT #58

Bedford Station, Harlem Railroad
1891
13¾ x 18
reproduced in Baur, p. 65

Black Mountain from Poplar Point
date unknown
15½ x 25½
ORT #95

Boating on Lake George
1870
16¼ x 26¼
NYNEX Corporation

Bowling Green, New York City
1868
33 x 48¼
New York Historical Society

Bridge over Waterfall
1855
10½ x 13⅝
Photo at Hirschl & Adler Galleries

Brook Study at Warwick
1873
26 x 40
Munson-Williams-Proctor Institute

Buck Mountain — Lake George
c. 1894
size unknown
NAD 1895 no. 282

Buck Mountain, Lake George
1867
30¼ x 50½
Reproduced in Baur, p.53

Buck Mountain, Lake George
1872
15⅛ x 25
Private Collection

Butternut tree
1874
18 x 14
Private collection

By the River
date unknown
27 x 36
Private collection (IAP)

Camel's Hump from Duxbury, N.Y.
date unknown
13 x 21
ORT #48

Cascading Woodland Stream
1867
9 x 7½ (oval)
Private Collection

Cat Mountain, Lake George,
From a Point Opposite Bolton
1873
8½ x 12¼
IAP

Catskill Clove
1849
21 x 17
SPB sale no. 3399 (9/13/72) #43

Catskill Scene
date unknown
9 x 14
Private collection

Cedars at Ramapo
date unknown
13½ x 23½
ORT #78

Chestnut Grove, Dashville, New York
date unknown
8¼ x 11
IAP

Chestnut Tree at Coldspring, N.Y.
date unknown
16½ x 22½
ORT #34

Chestnuts Near Rosendale,
Ulster County, New York
date unknown
15½ x 25½
ORT #30

Chestnuts near Rosendale,
Ulster Co., New York
date unknown
15½ x 25½
ORT #80

Children's Playground at Dashville,
Ulster Co., New York
1873
13 x 21
IAP

Children's Playground, Dashville,
Ulster County
1873
21 x 13½
Photo at Knoedler Galleries

Chocorua Mountain, N.H.
date unknown
13½ x 21½
ORT #35

Chocorua Peak, New Hampshire
1856
19⅛ x 28¼
Private collection

Coast of Maine
1873
11 x 20
Location unknown

Cold Spring, New York
date unknown
16½ x 22½
ORT #45

Connecticut River, near Lancaster,
New Hampshire
1875
12⅛ x 20⅛
Fine Arts Museums of San Francisco

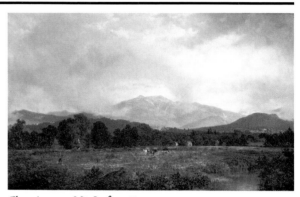

Clearing — Mt. Lafayette,
New Hampshire
1887
26⅜ x 40⅝
Collection Walker Art Center, Minneapolis:
Gift of the T.B. Walker Foundation, 1888

Conway Valley, New Hampshire
1859
5⅛ x 8¼
Reproduced in Baur, p. 44

Cornwall on the Hudson
1868
14 x 22
Museum of Fine Arts, Boston

Cos Cob, Connecticut
date unknown
13½ x 21½
ORT #41

Dashville, Ulster Co. New York
date unknown
9½ x 15½
ORT #43

Dresden, Lake George
date unknown
15½ x 25½
ORT #29

Dresden, Lake George
date unknown
13 x 21
ORT #7 or #42

Eagle Cliff
1869
31 x 25
Reproduced in Baur, p. 54

Eagle Cliff, Franconia Notch,
New Hampshire
1864
27¼ x 44½
Amon Carter Museum

Echo Lake
date unknown
8½ x 12
location unknown

Echo Lake, New Hampshire
1867
30 x 40
Private collection

Elms at Geneseo, New York
date unknown
13½ x 21½
ORT #104

Esopus Creek
1863
27 x 44
Reproduced *Kennedy Quarterly,*
vol. 10, no. 4 (1971), p. 202

Esopus Creek at Hurley
1858
10½ x 16½
IAP

Esopus Creek at Hurley
date unknown
15½ x 25½
ORT #50

Esopus Creek on the Unadilla,
New Berlin, Chenango County New York
date unknown
30 x 40
Reproduced *Kennedy Quarterly,*
vol. 10, no. 4 (1971) p.201

Evening
1877
16 x 26
Location unknown

Falls at Dresden, Lake George
date unknown
19½ x 15½
ORT #37

Fannie Glen, New Jersey
1850
17 x 22¾
Private collection

Farm on the Genesee River
date unknown
12 x 18
Photo at Hirschl & Adler Galleries

Figure in a Landscape
1865
5½ x 8½
SPB sale no. 4112 (4/21/78) #15

Figure in a Landscape
date unknown
12 x 20
IAP

Forest Rocks
1851
17 x 21
Cleveland Museum of Art

Fort Montgomery on the Hudson
date unknown
13 x 20½
ORT #76

Foundry at Cold Spring
date unknown
19¼ x 27¼
Private collection

Fourteen Mile Island
c. 1873
size unknown
NAD 1874 no. 385

Fourteen Mile Island, Lake George
date unknown
9½ x 15½
ORT #62

Franconia Mountains, N.H.
1867
15½ x 27
Art Market

Genesee River
1888
15½ x 22½
Memorial Art Gallery
of the University of Rochester

Genesee Scenery, New York
1872
13¼ x 21¼
Reproduced in Baur, p. 57

Greenwood Lake, New Jersey
1889
16 x 20
SPB sale no. 3913 (10/28/76) #90

Greenwood Lake, Orange County,
New York
1873
12 x 20
Private collection

Group of "Wood Elm"
date unknown
13 x 16½
IAP

Hague-Lake George
1860
12¼ x 20
Art Market

Haines Falls in Catskill Clove
date unknown
20 x 17
ORT #90

Haines Falls, Kauterskill Clove
1849
16 x 14½
Private collection

Harbor Island, Lake George
1871
16⅜ x 26¼
Private collection

Harbor Island, Lake George
date unknown
14 x 29
Reproduced *Kennedy Quarterly,*
vol. 7, no. 3 (1967) p. 162

Harbor Island, Lake George
date unknown
13½ x 23½
ORT #14

Harbor Island, Lake George
date unknown
25½ x 14½
ORT #79

Harlem River, Aqueduct
1860
7½ x 13
Hirschl & Adler Galleries

High Bridge
c. 1860
5 x 4
Private collection

High Bridge, Harlem River
1860
11 x 18
Private collection

Highland Falls, West Point
1869
16 x 24
Phoenix Art Museum

Homestead at Plainfield, New Jersey
date unknown
8 x 10½
Private collection

Homestead at Shark River
1879
11⅝ x 15¼
Pioneer Museum & Haggin Galleries

House in the Woods
date unknown
5⅜ x 8¼
Christie's sale no. 5794 (12/7/87) #10

Hudson Highlands Sunset
date unknown
9¼ x 13¾
SPB sale no. 3638 (5/11/74) #205

Hudson River
date unknown
9¼ x 16
Photo at Hirschl & Adler Galleries

Hudson River From Fort Montgomery
1870
38½ x 60
Private collection

Hudson River Landscape
date unknown
16 x 24
Location unknown

Hudson River Reminiscence
1869-70
14 x 22
Private collection

Hudson River Scene
with Mother and Child
1886
23⅛ x 29½
IAP

Hudson River View
date unknown
8 x 10
IAP

Hudson River Near Kingston
1872
28 x 38
Photo at Vose Galleries, Boston

Hyde Park
1869
13 x 21½
Photo at Saks Gallery

Idlewild on the Hudson,
Mouth of the Moodna
date unknown
15½ x 25½
ORT #83

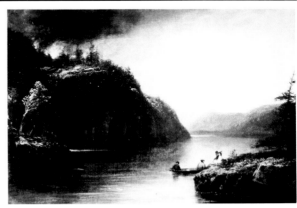

Fire on Black Mountain
1870
12 x 16½
Private collection

Indian Falls: A Study
date unknown
20½ x 16½
ORT #101

James River, Virginia
1860
7 x 12
Reproduced *Kennedy Quarterly,*
vol. 10 (1971), p. 222.

Joyceville, Connecticut
date unknown
13 x 21½
ORT #102

Lake George
1865
6 x 9
Photo at Childs Gallery, Boston

Lake George
1871
38½ x 60
SPB sale no. 848 (3/13/47) #523

Lake George
1870
10¼ x 16
Photo at Vose Galleries, Boston

Lake George
date unknown
17½ x 9¾
Art Market

Lake George
date unknown
13½ x 21½
Photo at Vose Galleries, Boston

Lake George
c. 1859
size unknown
NAD 1860 no. 166

*Lake George Looking North from
Tongue Mountain Shore*
1874
14⅛ x 22⅛
The Adirondack Museum

Lake George from Dollar Island
date unknown
15½ x 25½
ORT #53

Lake George from Dresden
c. 1857
size unknown
NAD 1858 no. 187

Lake George from Dresden
date unknown
14½ x 25½
ORT #72

*Lake George from
the Ruins of Fort George*
1870
18 x 30
Private collection

Lake Winnipesaukee, New Hampshire
1867
28 x 44
Photo at Kenneth Lux Gallery

Lancaster, N.H.
1867
15 x 25
SPB sale no. 3548 (9/28/73) #71

Landscape
1871
18⅛ x 30
Pioneer Museum & Haggin Galleries

Landscape
date unknown
8 x 11
George Walter Vincent Smith
Art Museum

Landscape
1850-70
28 x 40
Nassau County Museum

Landscape
1855
17 x 23
Reproduced in Baur, p. 40

Landscape
1875
15½ x 24
Private collection

Landscape
date unknown
9¾ x 15¾
Private collection

Landscape
date unknown
6 x 9
Private collection

Landscape
date unknown
5⅞ x 7½
Private collection

Landscape
date unknown
5½ x 8
Private collection

Landscape
date unknown
5½ x 8½
W.M. Chase sale (1917) #104

Landscape
1856
9⅞ x 12
Photo at Alexander Gallery

Landscape "Lake Scene"
date unknown
7 x 11
Photo at Alexander Gallery

Landscape and Sheep
date unknown
size unknown
NAD 1879 no. 466

Landscape and Stream with Fisherman
date unknown
15¼ x 19¼
Mead Art Museum

Landscape by a River
1873
14⅛ x 21
Private collection

Landscape with Autumn Trees
date unknown
10 x 12⅛
IAP

Landscape with Cattle
date unknown
9 x 13
SPB sale no. 998 (10/27/48) #54

Landscape with Cows
date unknown
12½ x 16¼
SPB sale no. 4116 (4/27/78) #582

Landscape with Cows
date unknown
size unknown
Photo at Vose Galleries, Boston

Landscape with Falls and Stream
1867
9 x 7½ (oval)
Photo at Alexander Gallery

Landscape with Figures in a Boat
date unknown
5⅞ x 4¾
The Museums at Stony Brook

Landscape with River — Setting Sun
1858
14 x 24
SPB sale no. 217
(Los Angeles 11/7/77) #290

Landscape with Waterfall
date unknown
9½ x 12¾
Photo at Hirschl & Adler Galleries

Landscape with a Bluff
1868
7 x 12
Private collection

Landscape, Pompton, N.J.
1879
18 x 27
SPB sale no. 2087 (2/16/62) #282

Landscape: New Berlin, N.Y.
date unknown
12¼ x 9
SPB sale no. 2087 (2/16/62) #257

Last Load at Kirkwood, NY
c. 1880
12 x 16
SPB sale no. 4841M (4/23/82) #30B

Livingston County
1858
20 x 30
SPB sale no. 3255 (10/27/71) #142

Marlborough Lake Scene
1870
11⅛ x 18⅛
Christie's sale no. 6610 (5/26/88) #13

Meadow at Genesee
date unknown
14¼ x 20½
IAP

Meadows on the Ramapo
date unknown
13 x 21
ORT #93

Memories of Adirondacks
date unknown
10 x 8
IAP

*Moat Mountain, New Hampshire
(Study)*
1851
16 x 23
Reproduced in Baur, p. 37

Morning at Harbor Islands, Lake George
1879
10¼ x 19½
Private collection

Morning at Ramapo
date unknown
10½ x 16
ORT #38

*Morning at the Harbor Islands,
Lake George*
c. 1877
size unknown
NAD 1878 no. 478

Mount Chocorua, New Hampshire
1851
16 x 23
Private collection

Mount Elephant, Lake George
1874
12¼ x 20
Sweet Briar College

Mount Lafayette
c. 1874
size unknown
NAD 1875 no. 389

*Mount Lafayette from Mill Pond,
Franconia, New Hampshire*
1871
15 x 26
Reproduced in Baur, p. 55

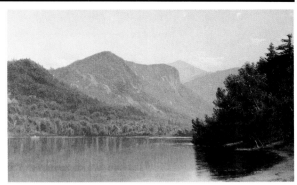

Mountain Lake Landscape
date unknown
11½ x 18¼
Mead Art Museum, Amherst College
Gift of Mrs. Winifred Arms

Mount Lafayette, New Hampshire
1871
10¼ x 17
SPB sale no. 453 (4/14/43)

Mountain Landscape
date unknown
size unknown
Private collection

Mountain Landscape
1865
20 x 30
Private collection

Mouth of the Moodna on the Hudson
1869
size unknown
location unknown

Mt. Lafayette
date unknown
13 x 19½
ORT #65

*Mt Lafayette from near
Bethlehem, New Hampshire*
date unknown
14 x 25½
ORT #51

Mt. Lafayette, New Hampshire
date unknown
8½ x 15
ORT #21

Narrows of Lake George
date unknown
5½ x 7¾
SPB sale no. 4268 (6/21/79) #226

Narrows, Lake George
c. 1857
size unknown
NAD 1858 no. 103

Natural Bridge
1860
3½ x 2 (oval)
Private collection

Natural Bridge of Virginia
1860
24 x 20
Private collection

Natural Bridge, VA
1860
14½ x 22¼
Reynolda House

Near Elizaville, N.Y.
date unknown
12 x 16
W.M. Chase sale (1917) #305

Near Franconia, New Hampshire
date unknown
11½ x 9½
ORT #82

Near Littleton, N.H.
c. 1866
size unknown
NAD 1867 no. 302

Near Milford
1875
9 x 11
Photo at Vose Galleries, Boston

Near Noroton, Connecticut
c. 1875
size unknown
NAD 1876 no. 269

Near Powder House, Central Park
date unknown
13 x 20½
ORT #32

Near Rosendale, Ulster Co., N.Y.
date unknown
14½ x 23½
ORT #18

Near Sabbath Day Point, Lake George
c. 1857
size unknown
NAD 1858 no. 180

Near Squam Lake, New Hampshire
1856
19 x 28
Metropolitan Museum of Art

Near Warwick, New York
1873
14¼ x 12¼
Art Market

Near Warwick, New York
c. 1873
16½ x 24
Herbert F. Johnson Museum of Art

Near Warwick, Orange County
date unknown
size unknown
Art Market

New Jersey Farmstead
date unknown
8½ x 12¾
Christie's sale no. 5272 (6/3/83) #12

New York Landscape
1875
5 x 7¾
Art Market

Beacon Rock, Newport
1873
11 x 20
Private collection

Noroton, Connecticut
1875
14¼ x 24¼
Private collection

North Conway, New Hampshire
1852
16 x 23
Museum of Fine Arts, Boston

Oak Trees Early Autumn
date unknown
18⅝ x 24½
IAP

*October at Ramapo,
Rockland County, NY*
1874
26¼ x 40¼
Reproduced in Baur, p.61

October on the Erie Railroad
c. 1873
size unknown
NAD 1874 no. 161

October-Cos Cob, Connecticut
1878
14 x 22
Huntington Museum of Art

Off Constitution Island
 1872
 15 x 26
 Photo at Chapellier Galleries

Old Bridge
 1872
 20 x 32
 IAP

Old House at Hurley
 date unknown
 10½ x 15½
 ORT #87

Old Kates Bridge, Ulster Co., NY
 c. 1871
 size unknown
 NAD 1872 no. 247

Old Man of the Mountains
 1876
 59¼ x 47⅛
 State of New Hampshire

Old Mill, West Milford, New Jersey
 1850
 17 x 23
 The Brooklyn Museum

Old Mill, West Milford, N.J.
 1850
 15¾ x 22⅞
 Photo at Hirschl & Adler Galleries

On Esopus Creek
 1876
 5¾ x 8¾
 Christie's sale no. 5238 (12/3/82) #8

On Shawangunk Lake
 date unknown
 22½ x 15½
 ORT #96

On the Androscoggin Near Shelburne
 1870
 12 x 21
 Photo at Vose Galleries, Boston

On the Connecticut at Lancaster
 date unknown
 15½ x 25½
 ORT #108

On the Delware at Hancock
 date unknown
 11½ x 17½
 ORT #52

On the Delaware at Hancock
 date unknown
 15½ x 23½
 ORT #57

On the Delaware at Hancock
 date unknown
 17½ x 23½
 ORT #111

On the Esopus
 1861
 10½ x 18¼
 National Academy of Design

On the Esopus at Hurley, New York
 1858
 14 x 24
 SPB sale no. 5584 (5/28/87) #46

On the Esopus, Ulster County, New York
 1859
 30 x 40
 Reproduced *Kennedy Quarterly*,
 vol. 10 no. 4 (1971), p. 202

On the Genesee
 1883
 8½ x 11
 IAP #99

On the Ramapo
 date unknown
 16½ x 12
 ORT #99

On the Ramapo
 date unknown
 21½ x 17½
 ORT #113

On the Ramapo River
 date unknown
 16 x 11
 ORT #15

On the Unadilla at New Berlin —
Chenango Co., NY
 1855
 15 x 20
 Reproduced in Baur, p. 40

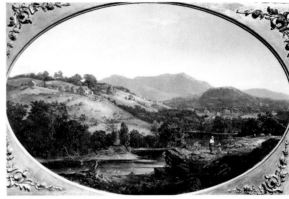

New Hampshire Landscape
 1855
 28 x 40 (oval)
 Photo at Knoedler Galleries

On the Unadilla at New Berlin,
Chenango Co., NY
 c. 1880
 size unknown
 NAD 1881 no. 447

On the Unadilla, at New Berlin, NY
 c. 1882
 18 x 26
 Alexander Gallery

On the Wa-Wa-Yanda
 1874
 8½ x 12¼
 SPB sale no. 3596 (1/26/74) #600

On the Wallkill
1874
4½ x 6½
Christie's sale no. 5282
(3/18/83) #145

On the Wallkill River
date unknown
size unknown
NAD 1869 no. 244

*On the Weinockie River,
Passaic County, New Jersey*
1879
18 x 26
SPB sale no. 81
(Los Angeles, 5/22/73) #41

Ossippee Lakes
date unknown
13½ x 21¾
IAP

Palisades
date unknown
7¼ x 10½
SPB sale no. 4650M (6/19/81) #65

Passing Shower
c. 1885
13 x 17
Mead Art Museum

Passing Shower
date unknown
12¼ x 16¼
SPB sale no. 4290 (10/20/79) #30

Pastoral Scene
1866
4 x 9
IAP

Pastoral Scene
1856
10¼ x 16
Reproduced in Baur, p.42

Pasture Road
1884
23 x 37
Metropolitan Museum of Art

Path Along a River
1862
10¼ x 8¼
Christie's sale no. 6402 (5/29/87) #64

Pathway Home
1884
18 x 14
Art Market

Perch
date unknown
21 x 17
Private collection

Phlox
1886
19¼ x 14½
Reynolda House

Placid Lake, Adirondacks
1868
size unknown
Private collection

Point Pleasant, Squan Beach, N.J.
1877
11¼ x 18½
SPB sale no. 316 (11/21/41) # 340

Pompton, N.J.
1879
14¼ x 22¼
Photo at Vose Galleries, Boston

Pompton, New Jersey
date unknown
17½ x 25½
ORT #115

Potage Lake, Ramapo, New York
1873
10 x 15
Montclair Art Museum

Putman County Scenery
date unknown
10½ x 14
IAP

Rafting on Lake George — Roger's Slide
1860
26½ x 43
IAP

Ramapo: Rockland County, New York
1874
22 x 18
SPB sale no. 681 (5/31/45) #86

Ravine in the Catskills
1867
5 x 8½
Art Market

Recollection of Th. Rossiter
date unknown
4¾ x 6
location unknown

Redwood, N.Y.
1870
7½ x 6
Private collection

River Bend
date unknown
28¼ x 18
Photo at Knoedler Galleries

River Landscape at Sunset
date unknown
15¾ x 19⅜
National Museum of American Art

River Scene
1856
10½ x 16
SPB sale no. 2977 (1/28/70)#79A

Riverside At Cos Cob, Connecticut
1880
15¾ x 12¼
Photo at Adams Davidson Gallery,
Washington, D.C.

Roadside Study, Joyceville, Connecticut
1882
14 x 11
IAP

Roadside, Shark River, N.J.
1877
7¾ x 10¾
SPB sale no. 3305 (1/27/72) #93

Rocks at Dresden, Lake George
date unknown
13 x 21
ORT #105

Rocks at North Conway
date unknown
16½ x 20½
ORT #75

Rocks at Ramapo
date unknown
15 x 13
ORT #11

Rocks, Shawangunk Mountain
date unknown
16½ x 20½
ORT #77

Rodgers Slide, Lake George
1864
12 x 20
Private collection

Ruined Mill at the Lower Falls,
Genesee River
1855
3⅜ x 4⅞
Albany Institute of History and Art

Sages Ravine, Berkshire Hills, Conn.
date unknown
21½ x 17½
ORT #49

Scene at Bedford Station
date unknown
8 x 11
SPB sale no. 5280 (1/31/85) #227

Scene at Bethel, Maine
1866
14 x 22
Private collection

Scene at Conklin, Broome County
date unknown
13 x 17
SPB sale no. 5227 (10/26/84) #30A

Scene at Dashville, New York
1868
15 x 25
IAP

Scene at Hurley, New York
1859
10⅛ x 18⅛
Photo at Hirschl & Adler Galleries

Scene in Fairfield County, Connecticut
c. 1898
size unknown
NAD 1899 no. 13

Scene in New Hampshire
c. 1864
size unknown
NAD 1865 no. 385

Scene in Tamworth, New Hampshire
date unknown
size unknown
Photo at Vose Galleries, Boston

Scene near Chapinville, Connecticut
1886
5¾ x 7⅛
The Museums at Stony Brook

Scene on the Boquette, Essex Co. NY
1860
12 x 20
Art Market

Scene on the Hudson
c. 1874
size unknown
NAD 1875 no. 429

Scene on the Hudson River
unknown date
14 x 9
Private collection

Scene on the Upper Hudson
above Schuylerville
c. 1872
size unknown
NAD 1873 no. 302

Scenery at Georgetown, Connecticut
date unknown
12 x 18
SPB sale no. 4236 (4/20/79) #13

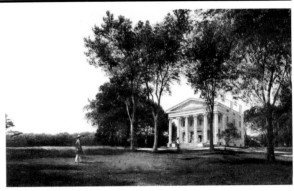

T.H. Faile's Residence, West Farms, NY
1873
10¾ x 17
Wellesley College Museum, Gift of
Mrs. Leeds A. Wheeler, (Marion Eddy,
Class of 1924), 1983.11

Scenery at Joyceville, Connecticut:
Storm Coming On
1877
14 x 20
Photo at Kenneth Lux Gallery

Scenery at New Berlin, New York
date unknown
12 x 9
IAP

Scenery on the Harlem River
c. 1860
size unknown
NAD 1861 no. 391

Scenery on the Weinockie, New Jersey
1880
13¾ x 19¾
Reproduced in Baur, p. 63

Schooley's Mountain, New Jersey
 date unknown
 18 x 23
 Photo at Chapellier Galleries

Sea Shore
 1877
 11¾ x 20⅝
 Robert Hull Fleming Museum,
 University of Vermont

September Afternoon
 1882
 17 x 26
 Stoekel House Collection,
 Yale University

Serenity
 date unknown
 7½ x 10½
 IAP

Shandaken Hills, Ulster County, NY
 1859
 7½ x 11½
 SPB sale no. 3348 (4/19/72) #39

Shandaken Hills, Ulster County, NY
 1859
 12 x 20
 Photo at Hirschl & Adler Galleries

Shark River, New Jersey
 date unknown
 9½ x 11½
 ORT #22

Shelving Rocks, Lake George
 date unknown
 15½ x 25½
 ORT #89

*Sketch of Apple Blossoms with
May Flowers*
 1873
 12½ x 9
 Private collection

Spring
 date unknown
 7½ x 10¼
 Photo at Alexander Gallery

Spring at Mount Vernon
 1876
 16 x 26
 Reproduced *Kennedy Quarterly,*
 vol. 5 no. 4 (1965), p. 27

Spring at Mount Vernon, New York
 1873
 13½ x 21½
 SPB sale no. 4290 (10/25/79) #14

Spring on the Bronx
 date unknown
 10½ x 16
 ORT #81

Spring on the Bronx River
 c. 1877
 14 x 22
 Private collection

Starr King Mountain, Lancaster, N.H.
 1869
 12 x 20
 Private collection

Stony Gap, New Hampshire
 date unknown
 22 x 30
 SPB sale no. 1551 (11/19/54) #56

Study
 c. 1864
 size unknown
 NAD 1865 no. 166

Study at Fort Montgomery, H.R.
 1869
 13 x 21
 SPB sale no. 4784M (1/28/82) #135

Study at Hurley, New York
 1858
 16 x 26
 Private collection

Study at Lancaster, New Hampshire
 1867
 15 x 25
 Photo at Hirschl & Adler Galleries

Study at Ramapo, N.Y.
 1873
 13⅞ x 21½
 IAP

Study at Ramapo, N.Y.
 1874
 14 x 12
 IAP

Study at Ranrapa
 1873
 9½ x 16
 Stoekel House Collection,
 Yale University

Study at Tamworth, New Hampshire
 1863
 9½ x 15
 Private collection

Study at Tamworth, New Hampshire
 1863
 16 x 12
 Art Market

Study at Tamworth, New Hampshire
 1863
 13⅝ x 16¾
 Kenneth Lux Gallery

Study at Warwick
 date unknown
 11 x 18
 Private collection

Study for Fort Montgomery
 1869
 16 x 26
 Private collection

Study from Nature
 c. 1876
 size unknown
 NAD 1877 no. 303

Study from Nature
 c. 1865
 size unknown
 NAD 1866 no. 451

Study from Nature, Walden Lake
1870
13½ x 21½
Photo at Bernard & S. Dean Levy Inc.

Study from Nature:
Dresden, Lake George
1870
15½ x 26
IAP

Study from Nature:
Dashville, Ulster County, NY
date unknown
14½ x 12¼
IAP

Study from Nature:
Pear Tree and Blossom
1874
20 x 13½
SPB sale no. 5124 (12/8/83) #113

Study near Lancaster, New Hampshire
1867
13 x 22
Private collection

Study near Tamworth, N.H.
1863
16½ x 13¾
D. Wigmore Fine Arts

Study near Trenton Falls, New York
1889
18½ x 26½
Kenneth Lux Gallery

Study near Warwick, N.Y.
1873
13¼ x 21¼
Private collection

Study of Nature, Dresden, Lake George
1870
13¾ x 21¾
Albany Institute of History and Art

Study of Rocks, Conway, N.H.
date unknown
16½ x 22½
ORT #2

Study of a Birch, View in Lancaster, N.H.
1867
16 x 26
Christie's sale no. 6512 (12/4/87) #27

Study of a Cedar
c. 1867
20 x 14
Montgomery Gallery

Study of a Pine, West Milford, N.J.
1850
21 x 17
Private collection

Study on the Housatonic
at West Cornwall
1875
8 x 13½
Photo at Kenneth Lux Gallery

Study, Bash Bish Falls
1856
15 x 20
Private collection

Study, Franconia Mountains
from West Campton, New Hampshire
date unknown
14½ x 26
Wadsworth Atheneum

Study, Placid Lake, Essex County, N.Y.
1869
11½ x 20
Private collection

Study, Pompton, N.J.
1879
18 x 26½
Private collection

Study, Pompton, New Jersey
1879
18¼ x 26¼
Private collection

Study, Pompton, New Jersey
1879
18 x 26
SPB sale no. 5207 (6/22/84) #43

Study, Ramapo (New York)
1873
7¾ x 12¼
Art Market

Summer Day
date unknown
9⅛ x 14
Photo at Vose Galleries, Boston

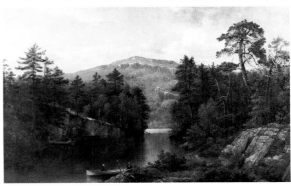

View on Lake George (Paradise Bay)
1876
26½ x 40½
Manufacturers Hanover Art Collection

Summer Landscape
date unknown
8 x 11
IAP

Sunset
date unknown
4¾ x 8
location unknown

Sunset, Fishing in New Rochelle
date unknown
12 x 16½
Reproduced in Baur, p. 59

Sunset, Hudson Valley
1872
3⁵⁄₁₆ x 4½
Reproduced in Baur, p. 59

Sunset, Warwick, New York
date unknown
13 x 21
ORT #106

Sycamores on the Ramapo
date unknown
15 x 25
ORT #73

Tamworth, New Hampshire
date unknown
13 x 19½
ORT #59

*The Bronx at Mount Vernon
on the Old Seton Farm*
date unknown
15½ x 25½
ORT #54

The Brook at Byfield, Massachusetts
1879
18 x 24
Photo at Vose Galleries, Boston

*The Connecticut River at North Littleton,
New Hampshire*
1867
14 x 22
Private collection

The Giant of the Meadow
1888-89
18 x 26¼
Location unknown

The Oaks at Geneseo
date unknown
13½ x 19½
ORT #64

The Old Sugar Maple
c. 1850-59
14½ x 12
Photo at Childs Gallery, Boston

The Tourn at Ramapo
date unknown
15½ x 25½
ORT #86

The Wallkill
1874
4⅜ x 6¼
Art Market

The Wallkill River
date unknown
12 x 16
Photo at Vose Galleries, Boston

*The Wallkill near Deckertown,
New Jersey*
date unknown
11½ x 15½
SPB sale no. 5524 (12/4/86) #28

The Watering Place
date unknown
12¼ x 15
SPB sale no. 102
(Los Angeles 11/28/73) #33

The Way to Church
1872
24 x 14
Photo at Knoedler Galleries

The Willows, Joyceville, Conn.
date unknown
17 x 25½
ORT #55

The Woodsman
date unknown
9 x 7 (arched top)
Photo at Hirschl & Adler Galleries

Three Pears and an Apple
1857
11⅜ x 16⅛
Private collection

Trenton Falls
1874
23 x 34½
Onondaga Historical Society

Trenton Falls
1866
10 x 13½
Christie's sale no.5372 (6/3/83) #33

Trout Brook
1879
14 x 20 (approx.)
Clark University

Ulster County Scenery
c. 1858
size unknown
NAD 1859 no. 606

Under an Oak
c. 1872-73
21 x 17
Reproduced in Baur, p. 58

Up the Hudson to West Point
1858
30 x 48
Fisher Gallery,
University of Southern California

*View at "Parker Hollow"
near Trenton Falls*
date unknown
18 x 22
Private collection

View at Cold Spring
c. 1855
size unknown
NAD 1856 no. 161

View at Dresden, Lake George
c. 1873
size unknown
NAD 1874 no. 315

View at Jackson, New Hampshire
1852
17 x 23
Photo at Bernard and S. Dean Levy, Inc.

View at New Berlin, Chenango Co., NY
c. 1869
size unknown
NAD 1870 no. 281

View at North Conway, N.H.
1875
21 x 17
Art Market

View at West Point
1860
10 x 16
Art Market

View at the Lower Falls, Genesee River
c. 1848
size unknown
NAD 1849 no. 216

View from New Windsor, Hudson River
1869
38 x 60½
Private collection

View from Union Hills, Hoboken
1862
9⅝ x 8
Photo at Adams Davidson Gallery,
Washington, D.C.

View in Essex County, New York
c. 1858
size unknown
NAD 1859 no. 240

View in Westmoreland
c. 1850
size unknown
NAD 1851 no. 78

View near Greenwich, CT
1878
14 x 19¾
Art Market

View near Shelburne, Vermont
1865
30 x 25
Photo at Knoedler Galleries

*View of Hudson River from
Ruins of Fort Putnam*
1867
14 x 22
IAP

View of Kingston, New York
date unknown
8 x 11½
location unknown

View of Lancaster, N.H.
1869
14½ x 22½
IAP

View of Linwood, Connecticut
1889
28 x 44
Art Market

View of Pompton, N.J.
1881
14.7 x 56.4 cm
Montreal Museum of Fine Arts

*View of West Point from
the Hudson River*
date unknown
9⅜ x 16
IAP

View of the Androscoggin River, Maine
1869
28 x 44
Private collection

View of the Wallkill River
1868
15 x 25
SPB sale no. 673 (5/10/45) #75

View on the Genesee River
c. 1849
size unknown
NAD 1850 no. 268

View on the Hudson River
date unknown
9½ x 16
Photo at Vose Galleries, Boston

View on the Palisades, H.R.
c. 1870
size unknown
NAD 1871 no. 312

View seen at Hurley, New York
date unknown
18 x 28
SPB sale no. 830 (1/23/47) #294

Village of Lancaster, New Hampshire
date unknown
15½ x 25½
ORT #8

Wallkill Scenery
date unknown
8¾ x 11¼
Brooklyn Museum

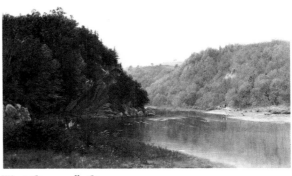

West Cornwall, Conn.
1875 18 x 26
University Art Museum, University
of Minnesota, Minneapolis, Purchase,
Special Projects Programs, Archie B.
and Bertha H. Walker 69.13

Warwick, Orange Co., NY
date unknown
16 x 10
Private collection

Water Falls at Ramapo
date unknown
21½ x 18 ORT #94

Weehauken, N.J.
date unknown
17 x 26
Photo at Vose Galleries, Boston

West Camden, New Hampshire
date unknown
14 x 10½
ORT #70

West Campton, New Hampshire
 1867
 14 x 20
 SPB sale no. 4236 (4/20/79) #15

West Cornwall, Conn.
 1875
 17 x 13¾
 Private collection

West Milford, New Jersey
 date unknown
 12½ x 20½
 Ort #3

West Point
 1870
 24 x 36
 IAP

West Point from Fort Putnam
 1867
 38 x 60
 Private collection

West Point, On the Hudson
 date unknown
 13 x 21
 ORT #12

Westfield Flats, New York
 1882
 7¾ x 12
 IAP

White Birch, Adirondacks
 date unknown
 20½ x 11
 ORT #98

*White Mountains from North Conway,
New Hampshire*
 date unknown
 15½ x 22½
 ORT #69

Willows, Joyceville, Connecticut
 date unknown
 17 x 25½
 ORT #114

Wood Interior
 date unknown
 8 x 7
 Photo at Vose Galleries, Boston

Wooded Landscape
 1871
 13½ x 11
 IAP

Woodland Interior
 date unknown
 9¼ x 12
 Photo at Vose Galleries, Boston

Woodland Pond
 date unknown
 6⅛ x 9¼
 IAP

Woodland Scene
 date unknown
 6½ x 9
 SPB sale no. 904 (11/28/47) #230

Woodland Stream
 date unknown
 12 x 14
 IAP

Woodland Stream, Autumn
 1867
 9 x 6 (oval)
 location unknown

Woods, Trenton Falls, N.Y.
 date unknown
 14 x 10
 Art Market

Young Elms
 1863
 17½ x 14½
 Private collection

Young Elms at West Campton, N.H.
 date unknown
 14 x 22
 IAP

SELECTED BIBLIOGRAPHY

BOOKS

Avery, Samuel Putnam. *The Diaries 1871-1882 of Samuel P. Avery, Art Dealer*. Ed. Madeleine Beaufort, Herbert L. Kleinfield and Jeanne K. Welcher. New York: Arno Press, 1979.

Born, Wolfgang. *American Landscape Painting*. New Haven: Yale University Press, 1948.

Bryant, William Cullen. *Picturesque America or The Land We Live In, a Delineation by Pen and Pencil*. 1874. Secaucus, NJ: Lyle Stuart, 1974.

Buckell, Betty Ahearn. *Old Lake George Hotels: A Pictorial Review*. Lake George, NY: Buckle Press, 1986.

Campbell, Catherine H. *New Hampshire Scenery: A Dictionary of Nineteenth-Century Artists of New Hampshire Mountain Landscapes*. Canaan, NH: Published for New Hampshire Historical Society, by Phoenix Publishing, 1985.

Champlin, Jr., John Denison and Charles C. Perkins, editors. *Cyclopedia of Painters and Paintings*. 9 volumes. New York: Charles Scribner's Sons, 1886.

Champney, Benjamin. *Sixty Years' Memories of Art and Artists*. Woburn, Mass.: Wallace & Andrews, 1900.

Clark, Eliot C., N.A. *History of the National Academy of Design 1825-1953*. New York: Columbia University Press, 1954.

Clement, Clara Erskine and Laurence Hutton. *Artists of the Nineteenth Century and Their Works: A Handbook*. 1880. New York: Arno Press, 1969.

Cowdrey, Bartlett. *National Academy of Design Exhibition Record, 1826-1860*. New York: Printed for the New York Historical Society, 1943.

Cowdrey, Mary Bartlett. *American Academy of Fine Arts and American Art Union Exhibition Record 1816-1852*. New York: The New York Historical Society, 1953.

Crayon, Porte (David Hunter Strother). *Virginia Illustrated: Containing a Visit to the Virginian Canaan and the Adventures of Porte Crayon and His Cousins*. New York: Harper & Brothers, Publishers, 1857.

Cronon, William. *Changes in the Land: Indians, Colonists, and the Ecology of New England*. New York: Hill and Wang, 1983.

Cummings, Thomas S. *Historic Annals of the National Academy of Design*. New York: Kennedy Galleries, Inc., 1969.

Falk, Peter Hastings, editor. *Who Was Who in American Art*. Madison, CT: Sound View Press, 1985.

Fielding, Mantle. *Dictionary of American Painters, Sculptors, and Engravers*. New Completely Revised, Enlarged and Updated Edition. Poughkeepsie, NY: Apollo Books, 1983.

Gerdts, William H. and Russell Burke. *American Still-Life Painting*. New York: Praeger Publishers, 1971.

Groce, George C. and David H. Wallace. *The New York Historical Society's Dictionary of Artists in America 1564-1860*. New Haven, CT: Yale University Press, 1957.

Hedrick, Ulysses P. *The Pears of New York*. Albany, NY: J.B. Lyon Company, 1921.

Howat, John K. *The Hudson River and its Painters*. Harmondsworth, Middlesex, England: Penguin Books, Ltd., 1972.

Lamb's Biographical Dictionary of the United States, 1904. "Johnson, David."

Lawall, David B. *Asher B. Durand: A Documentary Catalogue of the Narrative and Landscape Paintings*. New York: Garland Publishing, Inc. 1978.

Lawall, David Barnard. *Asher Brown Durand: His Art and Art Theory in Relation to his Times*. Ph.D. Diss. Princeton University, 1966.

Levy, Florence N., editor. *American Art Annual 1909-1910*. Vol. VII. New York: American Art Annual, Inc., 1910.

Marlor, Clark S. *A History of the Brooklyn Art Association with an Index of Exhibitions*. New York: James F. Carr, 1970.

Moore, James Collins. *The Storm and the Harvest: The Image of Nature in Mid-Nineteenth Century American Landscape Painting*. Diss. Indiana University, May 1974.

Museum of Fine Arts, Boston. *M. and M. Karolik Collection of American Paintings 1815 to 1865*. Cambridge, Mass.: Harvard University Press, 1949.

Nash, Roderick. *Wilderness and the American Mind*. Revised edition. New Haven, CT: Yale University Press, 1973.

Naylor, Maria. ed. *The National Academy of Design Exhibition Record, 1861-1900*. Two volumes. New York: Kennedy Galleries, Inc., 1973.

New Hampshire Atlas and Gazeteer. DeLorme Mapping Company, 1987.

New York State Atlas and Gazeteer. DeLorme Mapping Company, 1987.

Novak, Barbara. *American Painting of the Nineteenth Century: Realism, Idealism, and the American Experience*. New York: Praeger, 1969.

_____ *Nature and Culture: American Landscape and Painting 1825-1875*. New York: Oxford University Press, 1980.

Rosenberg, John D. *The Genius of John Ruskin: Selections from his Writings*. New York: George Braziller, Inc., 1965.

Ruskin, John. *Modern Painters*. 1843; New York: Wiley and Son, 1868.

Sears, Clara Endicott. *Highlights Among the Hudson River Artists*. Boston: Houghton Mifflin Company, 1947.

Spassky, Natalie et al. *American Paintings in the Metropolitan Museum of Art. Volume II: A Catalogue of Works by Artists Born Between 1816 and 1845*. Edited by Kathleen Luhrs. New York: The Metropolitan Museum of Art in Association with Princeton University Press, 1985.

Stein, Roger B. *John Ruskin and Aesthetic Thought in America, 1840-1900*. Cambridge: Harvard University Press, 1967.

Talbot, William. *Jasper F. Cropsey 1823-1900*. Diss. New York University, 1972. New York: Garland Publishing Co., 1977.

Thomas, Howard. *Trenton Falls: Yesterday and Today*. Prospect, NY: Prospect Books, 1951.

Tuckerman, Henry T. *Book of the Artists, American Artists Life*. New York: G.P. Putnam and Son, 1867.

Whittredge, Worthington. *The Autobiography of Worthington Whittredge*. Ed. John I.H. Baur. 1942; New York: Arno Press, 1969.

Wilmerding, John, et al. *American Light: The Luminist Movement, 1850-75: Paintings, Drawings, Photographs*. Washington, DC: National Gallery of Art, 1980.

CATALOGS

Anderson, Patricia. *The Course of Empire: The Erie Canal and the New York Landscape*. Rochester, NY: Memorial Art Gallery of the University of Rochester, 1984.

Baur, John I. H. and Margaret C. Conrads. *Meditations on Nature: The Drawings of David Johnson*. Yonkers, NY: The Hudson River Museum of Westchester, Inc., 1987.

Bermingham, Peter. *Jasper F. Cropsey 1823-1900: A Retrospective View of America's Painter of Autumn*. College Park, MD: University of Maryland Art Gallery, 1968.

_____ *American Art in the Barbizon Mood*. Washington, D.C.: Published for the National Collection of Fine Arts by the Smithsonian Institution Press, 1975.

Foshay, Ella M., Barbara Finney, and Mishoe Brennecke. *Jasper F. Cropsey: Artist and Architect*. New York: The New York Historical Society, 1987.

Burroughs, Bryson. *The Metropolitan Museum of Art Catalogue of Paintings*. Ninth edition. New York: Metropolitan Museum of Art, 1931.

Cibulka, Cheryl A. *Quiet Places: The American Landscapes of Worthington Whittredge*. Washington, D.C.: Adams Davidson Galleries Inc., 1982.

Clune, Henry N. and Howard S. Merritt. *The Genesee Country*. Rochester, NY: Memorial Art Gallery of the University of Rochester, 1976.

Corn, Wanda M. *The Color of Mood: American Tonalism 1880-1910*. San Francisco, CA: M.H. DeYoung Memorial Museum and the California Palace of The Legion of Honor, 1972.

Driscoll, John Paul and John K. Howat. *John Frederick Kensett: An American Master*. Worcester, MA: The Worcester Art Museum, 1985.

Ferber, Linda and William H. Gerdts. *The New Path: Ruskin and the American Pre-Raphaelites.* New York: The Brooklyn Museum and Schocken Books Inc., 1985.

Ferber, Linda. *William Trost Richards: American Landscape and Marine Painter.* Brooklyn, NY: The Brooklyn Museum, 1973.

Herbert, Robert L. *Barbizon Revisited.* New York: Clarke & Way, Inc., 1962.

Howat, John K. et al. *American Paradise: The World of the Hudson River School.* New York: The Metropolitan Museum of Art, 1987.

Howat, John K. *John Frederick Kensett 1816-1872.* New York: The American Federation of Arts, 1968.

Huntington, David C. *The Quest for Unity: American Art Between World's Fairs 1876-1893.* Detroit, MI: Detroit Institute of Arts, 1983.

Keyes, Donald et al. *The White Mountains: Place and Perceptions.* Hanover, NH: Published for the University Art Galleries, University of New Hampshire, Durham, by the University Press of New England, 1980.

Maddox, Kenneth W. *An Unprejudiced Eye: The Drawings of Jasper Francis Cropsey.* Yonkers, NY: The Hudson River Museum, 1979.

Myers, Kenneth. *The Catskills: Painters, Writers, and Tourists in the Mountains 1820-1895.* Yonkers, NY: The Hudson River Museum of Westchester, 1987.

Naef, Weston and James N. Wood. *Era of Exploration: The Rise of Landscape Photography in the American West, 1860-1885.* New York: Albright-Knox Art Gallery and The Metropolitan Museum of Art, 1975.

Ortgies & Co. *Catalogue of Paintings in Oil by David Johnson, N.A.* to be sold by auction February 13th-14th at Fifth Avenue art galleries...by Ortgies & Co. New York: 1890.

Owens, Gwendolyn and John Peters-Campbell. *Golden Day Silver Night: Perceptions of Nature in American Art 1850-1910.* Ithaca, NY: Herbert F. Johnson Museum of Art, Cornell University, 1982.

Rebora, Carrie. *Jasper Cropsey Watercolors.* New York: National Academy of Design, 1985.

Simpson, Pamela H. *So Beautiful An Arch: Images of the Natural Bridge 1787-1890.* Lexington, VA: Washington & Lee University, 1982.

Stein, Roger B. *Susquehanna: Images of the Settled Landscape.* Binghamton, NY: Roberson Center for the Arts and Sciences, 1981.

Talbot, William S. *Jasper F. Cropsey, 1823-1900.* Washington: Published for the National Collection of Fine Arts by the Smithsonian Institution Press, 1970.

PERIODICALS

_____ "American Studio Talk." *The International Studio* X (June 1900) No. 40 Supplement XIII-XVII.

Baur, John I.H. " '...the exact brushwork of Mr. David Johnson,' An American Landscape Painter, 1827-1908." *The American Art Journal* XII (Autumn 1980) pp. 32-65.

McCoy, Garnett, ed., "Jervis McEntee's Diary," *Archives of American Art Journal* VIII nos. 3 and 4 (July-October 1968) pp. 1-29.

Moure, Nancy Dustin Wall, "Five Eastern Artists Out West," *The American Art Journal* V (November 1973) pp. 15-31.